Penn's Cabin

BIGHORN CANYON
NATIONAL
RECREATION AREA

Bighorn River

Big Coulee

37

Sykes Ridge Road

SYKES RIDGE

Pass Highway

IDGE

Among Wild Horses

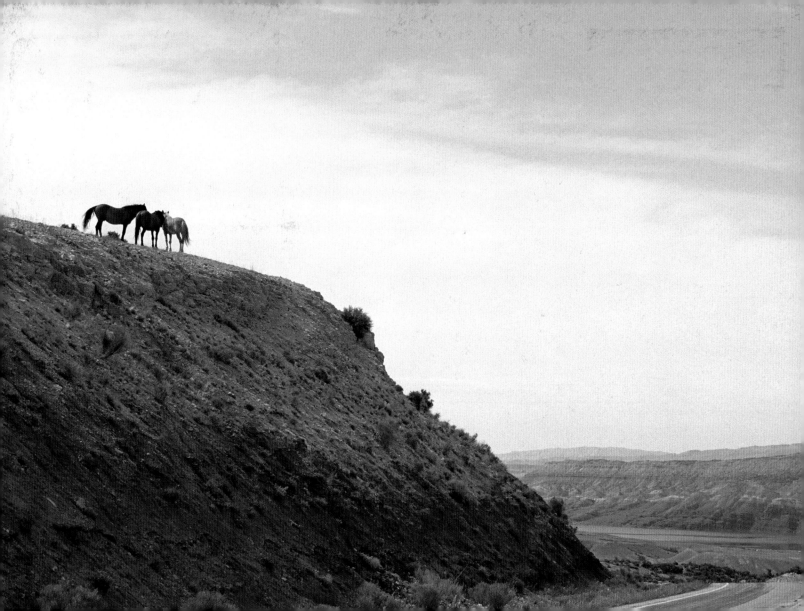

AMONG WILD HORSES

A PORTRAIT OF THE PRYOR MOUNTAIN MUSTANGS

Photography by LYNNE POMERANZ

Text by RHONDA MASSINGHAM

Foreword by HOPE RYDEN

Storey Publishing

The mission of Storey Publishing is to serve our customers by publishing practical information that encourages personal independence in harmony with the environment.

Edited by Deborah Burns
Art direction and text design by Mary Velgos
Cover design by Kent Lew and Mary Velgos
Text production by Liseann Karandisecky
Cover photographs by Lynne Pomeranz

Lyrics of "La Primera" by Ian Tyson © Slick Fork Music. Used by permission

Map on page 8 © 2006 by Kevin Kibsey
Photos © 2006 by Lynne Pomeranz
Text © 2006 by Storey Publishing, LLC

The information in this book is true and complete to the best of our knowledge. All recommendations are made without guarantee on the part of the author or Storey Publishing. The author and publisher disclaim any liability in connection with the use of this information. For additional information please contact Storey Publishing, 210 MASS MoCA Way, North Adams, MA 01247.

Storey books are available for special premium and promotional uses and for customized editions. For further information, please call 1-800-793-9396.

Printed in China by Regent Publishing Services
10 9 8 7 6 5 4 3 2 1

Library of Congress Cataloging-in-Publication Data

Massingham, Rhonda, 1959-
 Among wild horses / Rhonda Massingham ; photography by Lynne Pomeranz.
 p. cm.
 Includes index.
 ISBN 13: 978-1-58017-633-0; ISBN 10: 1-58017-633-X (hardcover w/ jacket : alk. paper) 1. Wild horses—Pryor Mountain Wild Horse Range (Mont. and Wyo.) 2. Wild horses—Pryor Mountain Wild Horse Range (Mont. and Wyo.)—Pictorial works. 3. Pryor Mountain Wild Horse Range (Mont. and Wyo.) 4. Pryor Mountain Wild Horse Range (Mont. and Wyo.)—Pictorial works. I. Title.

SF360.3.U6M37 2006
599.665'5—dc22

 2006017422

In tribute to all the wild horses
who live — and have died — in glorious freedom

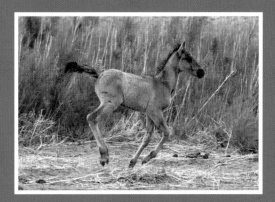

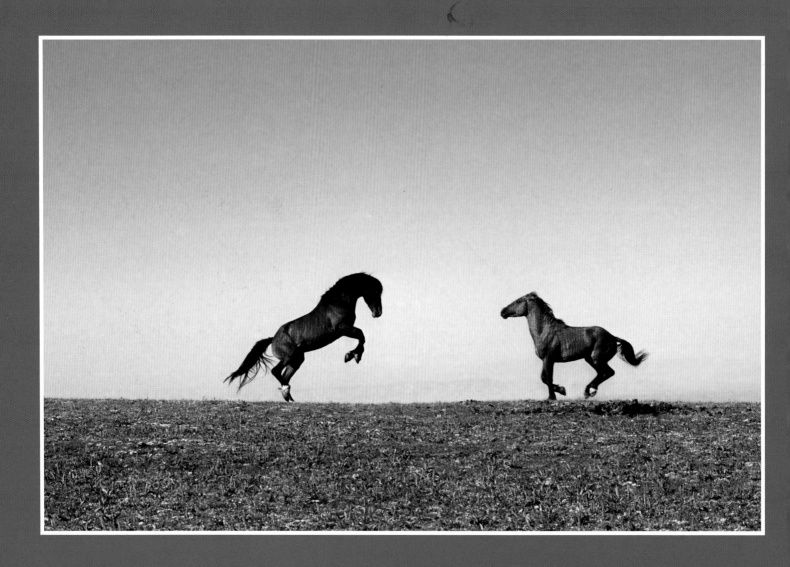

Contents

Foreword

How gorgeous are the wild horses of the Pryor Mountains! And how beautifully have Lynne Pomeranz and Rhonda Massingham rendered them. This book arouses memories of the years I spent admiring, photographing and writing about this special herd.

I first visited the Pryor Mountains in 1968 as producer of feature stories for ABC Network News, after being alerted to a government plan to dispose of the herd. In the eyes of the U.S. Bureau of Land Management wild horses were trespassers and overgrazing public lands. Unless removed, they claimed, this herd would die of starvation. People living in the nearby town of Lovell, Wyoming, disagreed with that assessment. They reported that the 200 horses on the mountain were in excellent shape, and they offered to sponsor the herd, even drop feed to the animals should such unlikely need arise.

This conflict, together with my footage of the horses, was aired on ABC News in July 1968, and the public responded with dismay to the government's plan. Nevertheless, the Bureau continued work on an expensive holding corral into which they planned to funnel the horses.

It was then that the Humane Society of the United States went to court and presented a photograph of the holding corral, the existence of which the Bureau had denied under oath. This so embarrassed Interior Secretary Stuart Udall that he immediately designated the Pryor Mountains a Wild Horse Range. Case closed!

And so this beautiful herd was first to gain legal status. Two years would pass before enactment of the Wild Horse and Burro Act extended protection to all wild horses.

Meanwhile, I was so taken by the existence of wild horses that I took a leave of absence from ABC to travel about the West, researching scattered herds of mustangs for a National Geographic *article and a book. I didn't know it at the time, but I had traded in my television career for a life of bliss — studying and writing about wild animals. It was the best decision I ever made!*

Thank you, Pryor Mountain wild horses. You changed my life!

— Hope Ryden, author, America's Last Wild Horses

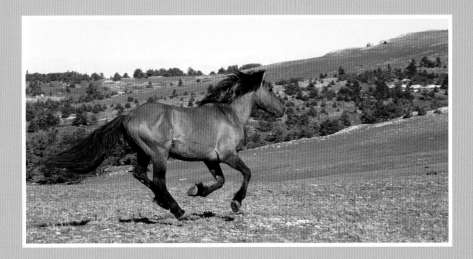

SHAMAN, AT 19, is the oldest band stallion on the Pryor Mountain Wild Horse Range.

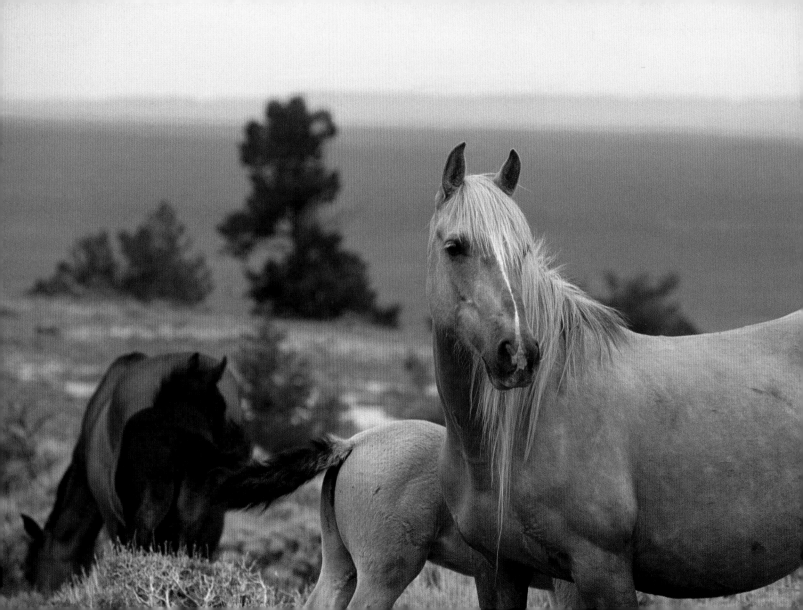

PREFACE

"The horses changed my life"

IT FEELS LIKE A FAIRY TALE COME TO LIFE: beautiful, wild horses running free in the mountains of Montana and high desert of Wyoming. They are regal, proud, spirited, watchful, wise . . . and very, very real.

Of all the wonders of the world, the survival of the horse as a species is a particular marvel. It is a story not of a few hundred years on the North American continent, or a few thousand years of domestication. It is a story of millions of years of evolution, adaptation, and survival. Subsisting on the poorest forage, equines can inhabit sparse, even hostile environments. The wild horses of the Pryor Mountains are a phenomenal part of this tremendous epic.

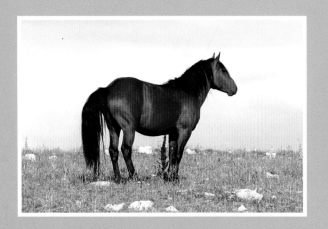

Preserving these animals' wild habitat and way of life has become a mission for a growing number of individuals who understand the unparalleled value of Nature's true fairy tales. The words "the horses changed my life" could be their anthem. How sincerely they are spoken. How reverently. How often! For these horses have a profound effect on people. They lift the spirits, quiet the mind, and soothe the soul.

To experience these mustangs in the wild is to witness a rare and exquisite example of Nature's glory. Bright, alert eyes sparkle with intelligence, lush manes and tails tantalize the wind, sinewy flesh and momentous bone gambol over ancient trails. Their very presence whispers an echo of another time. To be among them is to know a wildness unchanged by human will.

◀ LIVING FREE in a wild land is the birthright of all of America's mustangs.

(preceding pages)
◀◀ BLANCA AND FOAL. Shielding her foal, Blanca sniffs the wind.

(following pages)
▶▶ DARK BAY STALLION Morning Star, with two grulla mares and a light dun. According to Spanish traditions a male horse of this smoky color is grullo, and the female is grulla.

In their own way, these wild horses exemplify the best of what we hope for in ourselves: strength, courage, even kindness, forgiveness, and love. They endure and accept. They resolve their differences then move on. But what leaves us most wistful — what we envy most — is their raw, unabashed freedom. They neigh it on the mountain and whicker it from the desert. It races along high ridges and down grassy slopes, lolls in the warmth of the mountain sunshine, and wallows in the red mud of water holes. Joyful, lazy, exuberant and ultimately content: it is the freedom of these exquisite animals that catches our hearts.

To share in their tranquil existence, to realize the perfect order of their natural world, to rejoice in each new foal and yet be able to accept when that perfect order brings suffering or death — to know them on their own terms — is to be transformed.

We hope to convey them to you here as if you were among them, so that you can experience a small part of their world and appreciate their wonder. And hopefully you, too, will be able to say, "the horses changed my life."

"The Crow Country is a good country.
The Great Spirit has put it exactly in
the right place; while you are in
it you fare well; whenever you go
out of it, whichever way you travel,
you will fare worse. . . .
Everything good is to be found there.
There is no country like the
Crow Country."

— *Chief Eelapuash (also called Arapooish) to a fur trader in the 1830s*

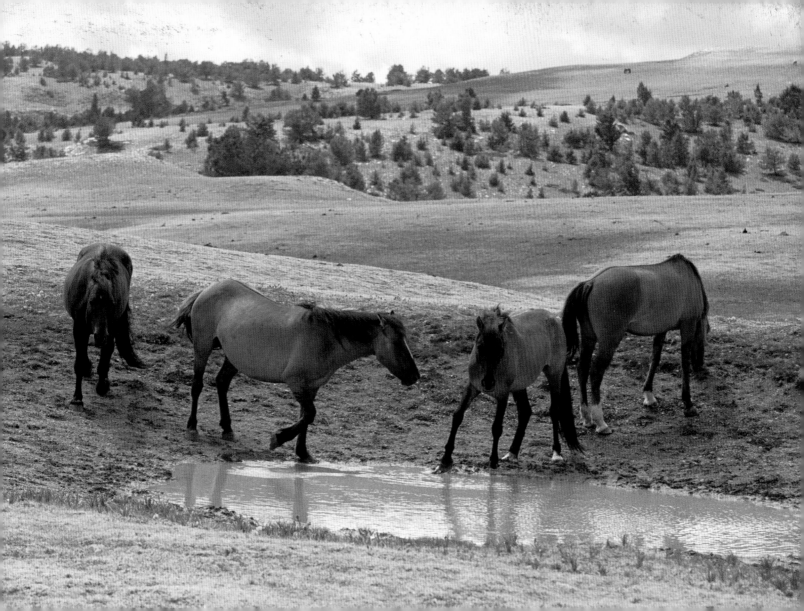

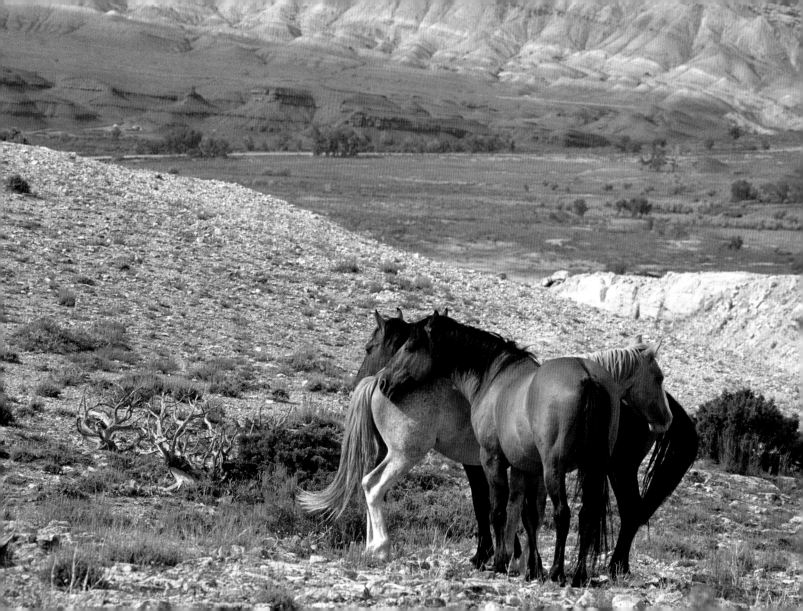

A Cathedral without Roof or Walls

THE PRYOR MOUNTAINS LIE ALONG THE WYOMING-MONTANA STATE LINE, about 13 miles north of Lovell, Wyoming, and 40 miles south of Billings, Montana. Rising to 8,822 feet, East Pryor Mountain materializes out of the desert like a dull beige mirage. From a distance, the looming monolith offers dismal prospects, appearing as a hulk of dusty rock and sparse, dry vegetation. Such is Nature's sleight of hand.

On September 9, 1968, Interior Secretary Stewart L. Udall officially designated 33,600 acres of Montana and Wyoming as the Pryor Mountain Wild Horse Range; today it includes approximately 39,650 acres between the Crow Indian Reservation and Custer National Forest. Although much of the terrain is too steep, rocky, or barren for wild horses to graze, its remoteness and inaccessibility preserve the isolation these mustangs have always known.

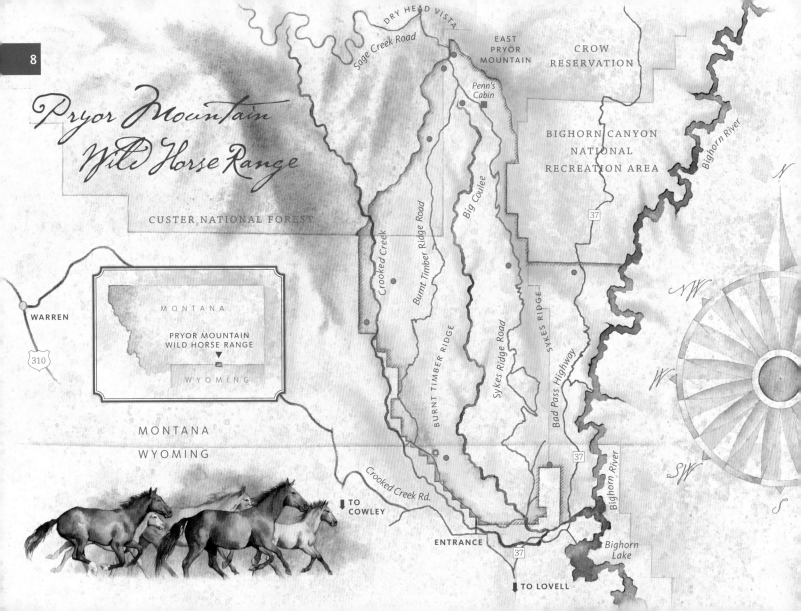

DRY HEAD VISTA

Sage Creek Road

EAST
PRYOR
MOUNTAIN

CROW
RESERVATION

Penn's
Cabin

BIGHORN CANYON
NATIONAL
RECREATION AREA

Bighorn River

Pryor Mountain
Wild Horse Range

CUSTER NATIONAL FOREST

Crooked Creek

Burnt Timber Ridge Road

Big Coulee

37

MONTANA

PRYOR MOUNTAIN
WILD HORSE RANGE

WYOMING

WARREN

310

BURNT TIMBER RIDGE

Sykes Ridge Road

SYKES RIDGE

Bad Pass Highway

N

NW

W

MONTANA

WYOMING

SW

S

Crooked Creek Rd.

37

Bighorn River

TO
COWLEY

ENTRANCE

37

Bighorn
Lake

TO LOVELL

Key

 WATERHOLES

WATER COURSES

HIGHWAYS

UNIMPROVED ROADS

ANNUAL ROUND-UP
AREA

0 1 2 3
SCALE IN MILES

◀ **THE PRYOR
MOUNTAIN WILD
HORSE RANGE,**
established in 1968,
predated federal
protection of wild
horses by three
years.

(preceding pages)

◀◀ **A BAND OF
BACHELORS**
lounges contentedly
in the rugged desert
of the Dry Head.

The Range includes high desert, rocky ridges, and semi-alpine slopes. Along the eastern boundary the Bighorn River carves through red rock and dun-colored soil, alive with sage and juniper, grasses, wildflowers, and forbs. To the west, Sykes Ridge and the Tillett or Burnt Timber Ridge rise up roughly 5,000 feet to converge at the top of the mountain with the vast Big Coulee Canyon yawning between them. At their southern base pockets of grass surround scant water holes. These different habitats separate three herds, with little interaction amoung them.

Reaching the top of the mountains is not for the faint of heart — or vehicle. There are several roads up: the rutted and ragged Sage Creek Road from the north, the rugged and jagged Burnt Timber Ridge Road to the southwest, and the incomparably frightful Sykes Ridge Road to the southeast. The easiest way to view horses is from the paved and scenic Bad Pass Road (Transpark Highway) that meanders through the length of the Dry Head.

Sage Creek Road gradually reveals a splendor undetectable from the desert below. Although it is snowbound much of the year, by late June wildflowers flood the wayside in waves of deep blue and purple, rippled with sudden yellow, white, or pink swells. Deep green cover swallows the land away from the road's edge, and nary a trace of beige is to be found.

Burnt Timber Ridge and Sykes Ridge wind through craggy, rock-strewn, ledge-hopping corners and sudden drop-offs before opening to the grandeur that awaits up the mountain.

At the top the views cascade into unadulterated, soul-expanding awe. These mountains, once known as *Baahpuuo Isawaxaawuua* ("Hitting the Rock Mountains") to the Crow (or Absarokee) Indians, became a sacred site long, long ago. Part of the Holy Land of a very spiritual culture, they remain the site of vision quests to this day. The scenery is spectacular, wildlife abounds, and there is a windswept newness in the air.

Descending, 200-year-old Douglas fir forests give way to sloping meadows that look down, out, and over the mere earthbound world below. The mountains seem to float above it all, unattached to the blur of a world left behind. Crow traditionalist John Pretty On Top described this place as "a cathedral without a roof, without a wall, it is forever, as far as you can see is what He has given you . . . that is how I see that mountain."

This diversity belies an even more colorful distant past for, until about 50 million years ago, there were no mountains here at all, only a vast and strangely populated sea. The high country still yields marine fossils. It is this strange, harsh, and rugged environment that helped form the remarkable character and temerity of the mustangs.

JUNE FINDS WILD HORSES working their way up the ridges to the plateaus in search of newly sprouted grass and forbs.

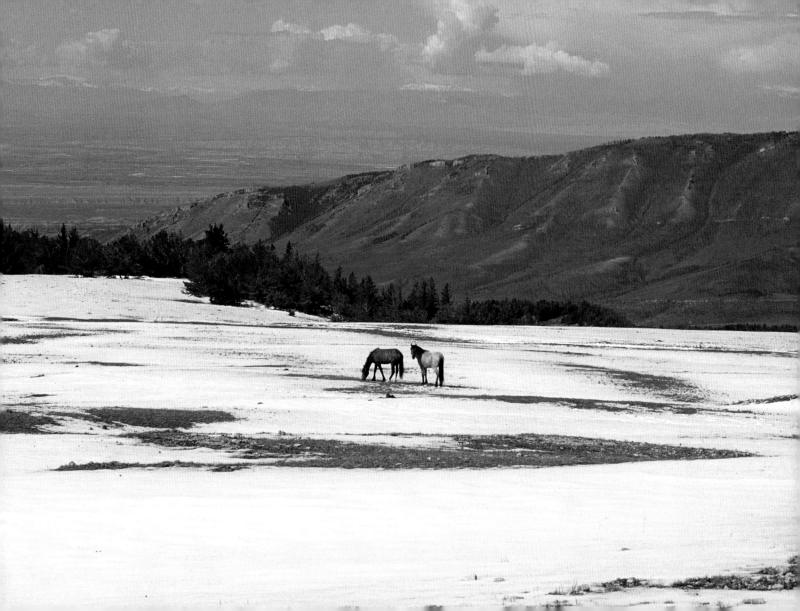

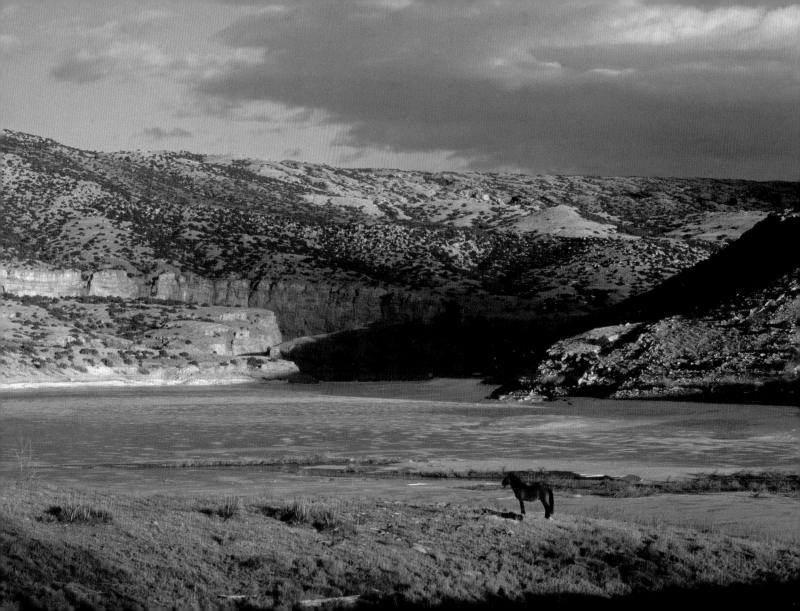

A World of Windy Extremes

THE CLIMATE IS AS CHALLENGING AS THE TERRAIN. At times the wind roars so relentlessly in the mountains that it tears away conversation between people standing only a few feet apart. Gusts of up to 70 miles per hour are not rare. In winter those winds bring blizzards. In summer they work with the sun to parch the open meadows.

Rainfall is sparse in the lower elevations — less than five inches per year — but on the mountain as much as 20 inches can drizzle, sprinkle, and hammer, bringing on the lush abundance of spring.

Snow falls nearly nine months of the year, often mounting to nearly three feet at the top and persisting there through June. Exposed ridges and mid-to-lower elevation plateaus are swept snow-free by the wind and the low winter sun's rays. Few weeks of the year see the mountain awaken to less than a sparkle of frost, even while the scrublands below sear in the summer heat. Warm weather brings biting flies, hailstorms, thunder, and murderous lightning. In recent years, drought has brought new challenges to the foraging horses, as well as to other wildlife and to land managers.

A LONE STALLION surveys a vast and varied landscape.

The Long Journey

HOW LONG HAVE HORSES BEEN IN THE PRYOR MOUNTAINS and where did they come from? With a history as rich as America's own, the Pryor Mountain mustangs' true origins may never be completely uncovered.

Equine evolution began more than 57 million years ago amid the lush vegetation of what was to become North America. Between 3.4 and 3.9 million years ago, early horses emerged, and over time, some wandered across the Bering Land Bridge into Asia. Between 13,000 and 11,000 years ago — shortly after man appeared in North America — many large species vanished from the continent, including the modern horse.

In the late fifteenth century, Spanish explorers returned the horse to its native land. Conquistadors arrived astride horses known as jennets, compactly built with a deep chest, an arched, somewhat heavy neck, a strong back, and a rounded croup that sloped to a low-set tail. The mane and tail were long, full, and a bit wavy. The facial profile was either straight or convex, with a broad forehead and deep-set, prominent eyes.

As settlers spread through North America, so did horses, many escaping to freedom. At their peak, wild horses were estimated to number in the millions. Horses may have

run wild around the Pryor Mountains for more than 200 years. Crow tradition first places horses nearby around 1725 when a war party brought a horse back from another tribe. By 1743, Hudson's Bay Company fur trader Louis-Joseph Laverendrie was awed by multitudes of fine Crow horses. Could the Pryor Mustangs be the remnants of Crow herds?

Over the years, trappers, explorers, traders, travelers, warriors, and settlers have surrendered horses to this high, wild frontier. In more recent times, horses abandoned by homesteaders due to drought and depression mingled with the wild herds. Few domestic horses, however, survived the rigors of this environment.

WHERE THESE HORSES came from may prove to be less of a mystery than where they are headed in the future.

Twentieth-century DNA testing proved that many Pryor Mountain Mustangs share a common ancestry with the Conquistadors' steeds. Perhaps even more precious is the tremendous genetic diversity this testing revealed, although already half their rare genes have disappeared as horses die or are removed from the Range.

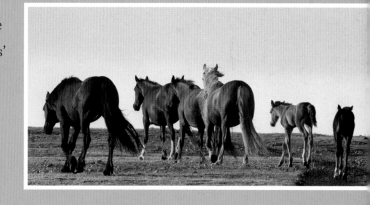

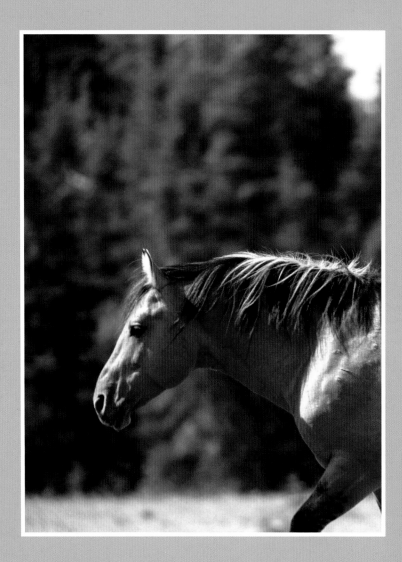

◄ SPANISH HERITAGE is unmistakable in some horses: the classic Iberian-Barb head, delicate features, small ears, long sloping nose, and sensitive, almost almond-shaped eyes that reflect a solemn serenity.

▶ WATER-HOLE RITUALS highlight the complex social order of wild horses. Alert and wary, band members enforce their established hierarchy. The lowest in the pecking order (left) approaches cautiously.

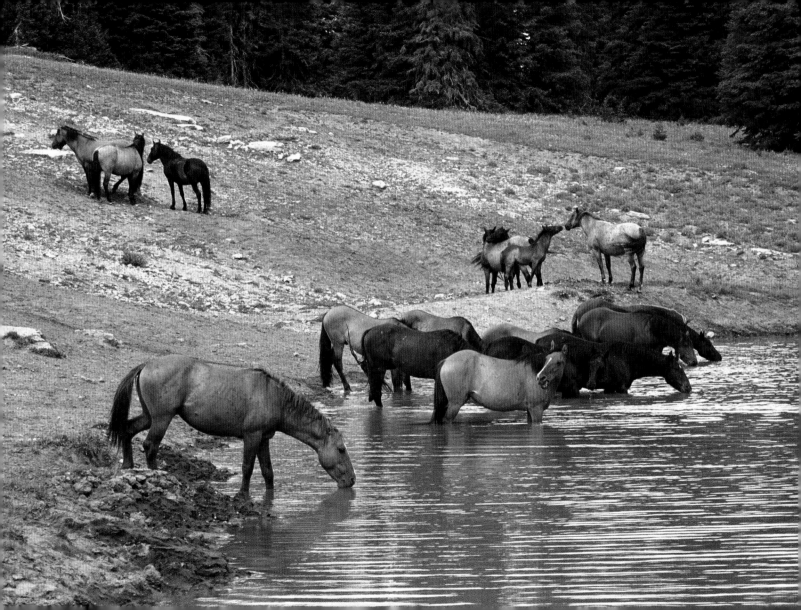

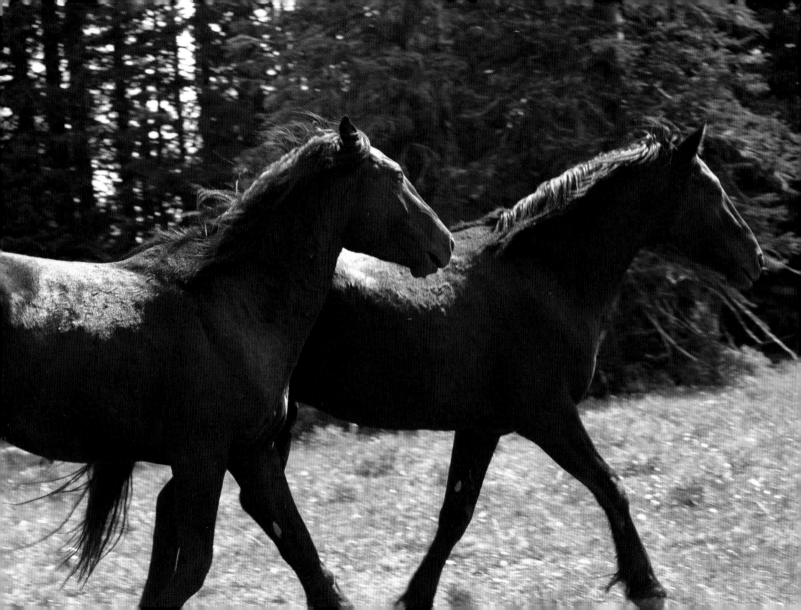

◀ **CLASSIC IBERIAN FEATURES** mingle with feathered fetlocks that suggest draft ancestry.

▶ **MEMBERS OF CONQUISTADOR'S BAND** are considered permanent trespassers for roaming the territory of their ancestors. Unbeknownst to them, it falls outside the Range.

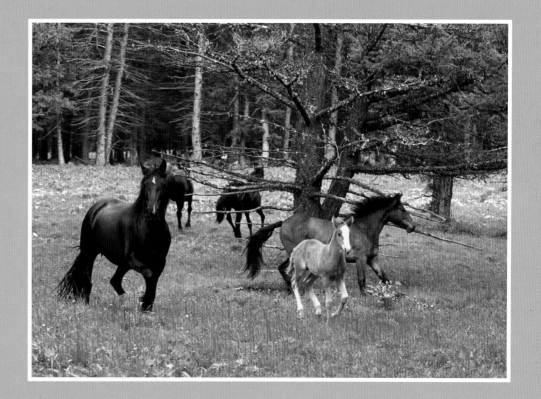

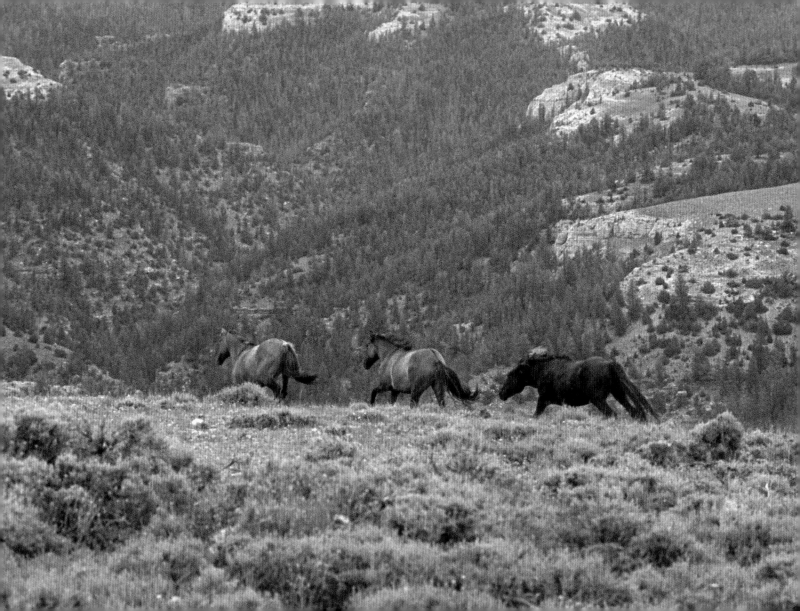

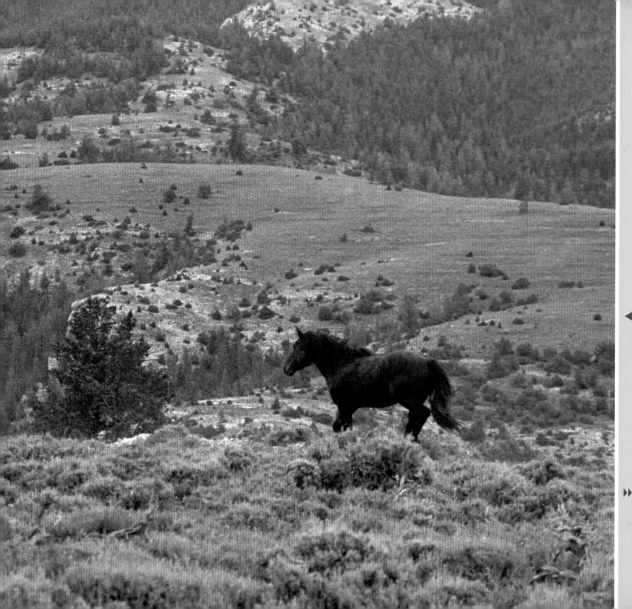

◀ RUNNING WILD
AND FREE as
Nature intended,
this group
disappears over
a ridge along the
lower plateaus
of the Pryor
Mountains.

(following pages)
▶▶ A TRUE COYOTE
DUN, Jackson's
coat bears the sooty
shadows for which
the color is named.

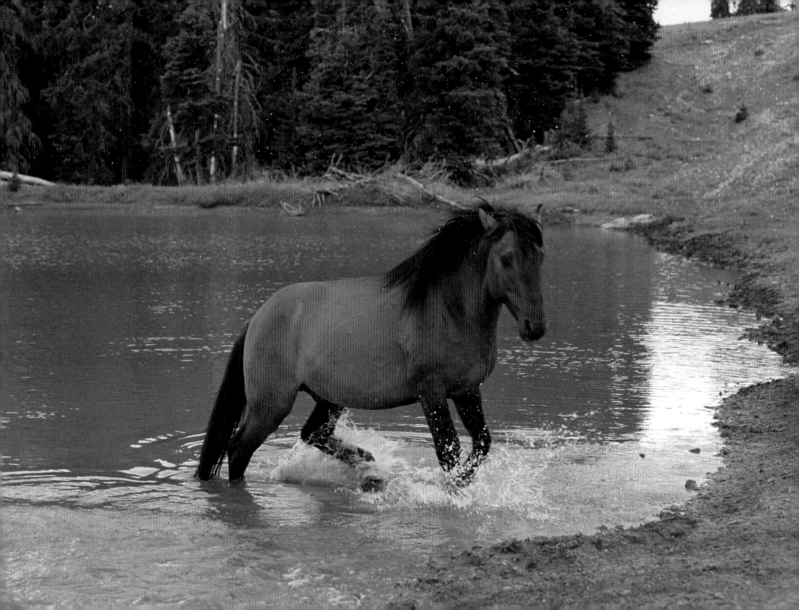

"I am a drinker of the wind
I am the one who never tires
I love my freedom more than all
these things. The Conquistador,
Comanche and the cowboy —
I carried them to glory.
I am La Primera — Spanish mustang
hear my story

"High in the Pryor Mountains
first light of dawn
Coyote Dun walks beneath the
morning star.
He became an outlaw . . .
his blood was watered some,
but the flame still burns
into the new millennium."

— *From "La Primera" by Ian Tyson*

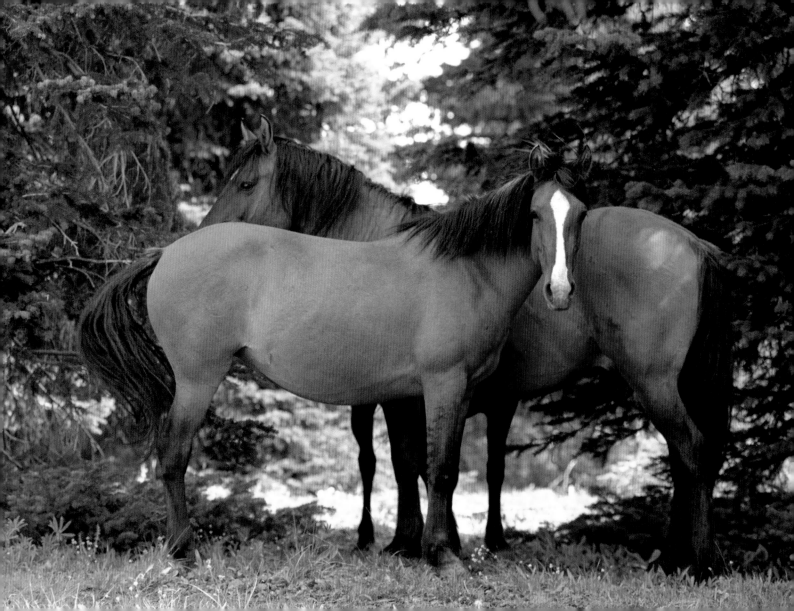

The Look of Eagles

MANY PRYOR MOUNTAIN MUSTANGS HAVE a distinct look — part Spanish heritage, part Pryor Mountain adaptation. Where Spanish breeding left off, the rigors of their adopted home took over.

There is often a resemblance to their jennet ancestors, with a twist. Their legs are straight with thick, dense bone. Tufts of hair or "feathers" adorn the fetlocks of many of the horses, which some observers attribute to draft horse blood, others to generations born to the cold. Chestnuts on hind legs may be tiny or missing altogether, typical of Spanish-blooded stock. Hooves are supremely healthy, thick, and strong.

On the average, the Pryor Mountain horses are taller and stouter than most other wild horses. Some mature at little over 13 hands (52 inches), yet possess great bone and substance, while others reach 15 hands (60 inches) with a leaner, lighter build.

Coat colors sparkle like the contents of a treasure chest. Golden duns are abundant, as are gunmetal grullos, onyx blacks, amber chestnuts, and deep garnet bays. A few copper-colored apricot duns, topaz palominos, and frosted, ruby-red and sapphire-blue roans decorate the Range, and a young sabino stallion offers the promise of future generations of white-splattered coats.

Dark or "primitive" markings on duns and grullos — leg bars (called zebra stripes), a dorsal stripe (lengthwise along the spine), and shoulder stripes that cross the withers — contrast vividly with gold and silver, apricot and deep gray-brown coats. Foreheads may sport a spider web pattern. The markings stand out most on newborn foals and fade somewhat as the horses mature.

This cluster of inherited traits is caused by the dun gene. Fairly common in horses of Spanish descent, it produces lightened coat colors and, often, primitive markings. Early roundups favored leaving these unusual colored and "Spanish-type" horses on the Range.

► LAKOTA'S BAND passes Cloud's band in the background. The band is the family unit, with one dominant stallion; occasionally a secondary, younger stallion; and from one to several mares and their foals and/or older offspring.

(preceding pages)
◄◄ THE HEALTH AND VIGOR OF THE HORSES reflects their natural suitability to the habitat. Here, a stallion, Looking Glass, and his mare, Sequoia, relax amid the abundance of summer.

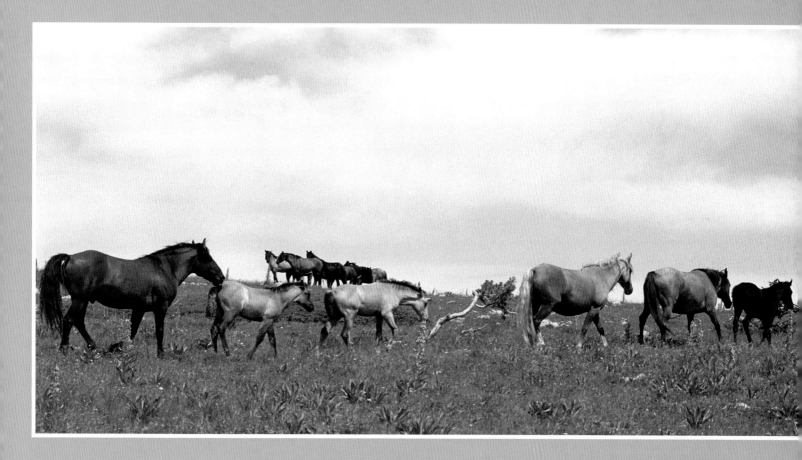

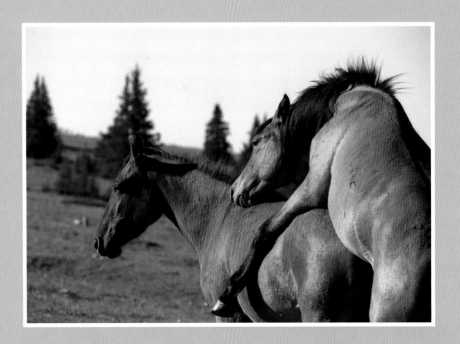

◀ A DUN STALLION, mounting a complacent mare, shows his dorsal (spinal) stripe, one of the primitive markings of the inherited dun gene.

▶ BRUMBY, A GRULLA, sniffs the air next to her dun mate, Jackson. The "frosting" in her mane, and in Baja's to her right, is another unusual aspect of the dun factor.

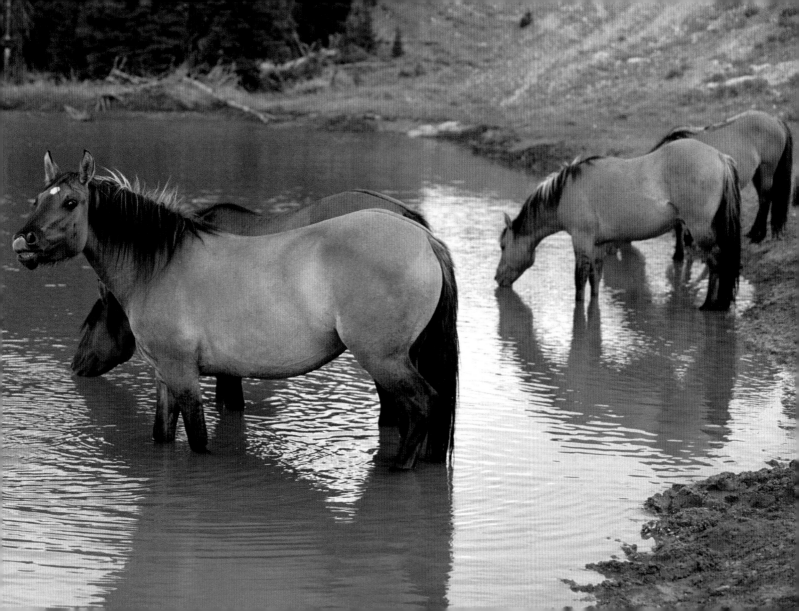

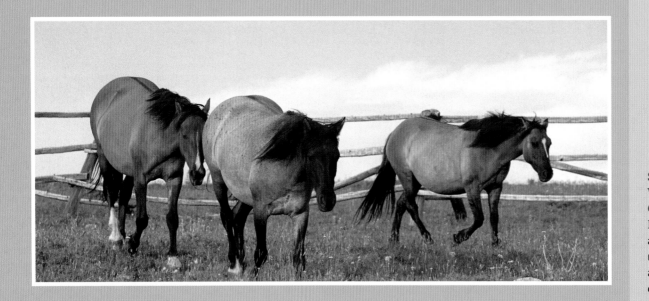

STUNNING VARIATIONS OF THE DUN FACTOR. Audubon, a black-faced grulla roan, and Exclaim, also grulla, show dorsal stripes and neatly black-edged ears — typical dun factor markings. In the image at left, Felina's red dun coat shows a lighter dorsal stripe.

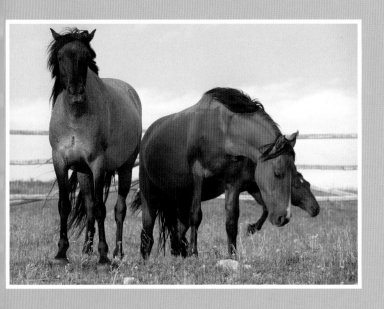 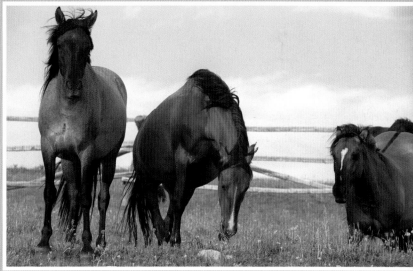

"You can never again re-create
what we have in the Pryor Mountain
horses because of their unique
genetic make-up and their
unique genetic heritage."

— *Rev. Floyd Schwieger, who studied the Pryor Mountain horses beginning in the 1960s and helped establish the Pryor Mountain Wild Horse Range, one of the first of its kind in the country, in 1968*

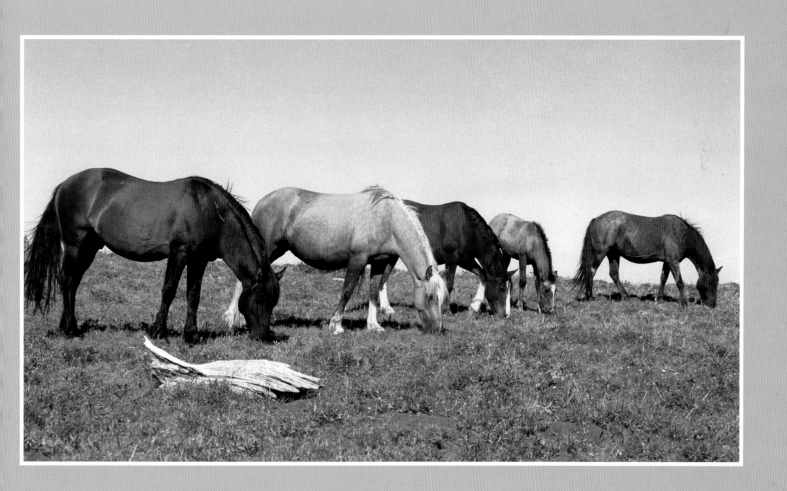

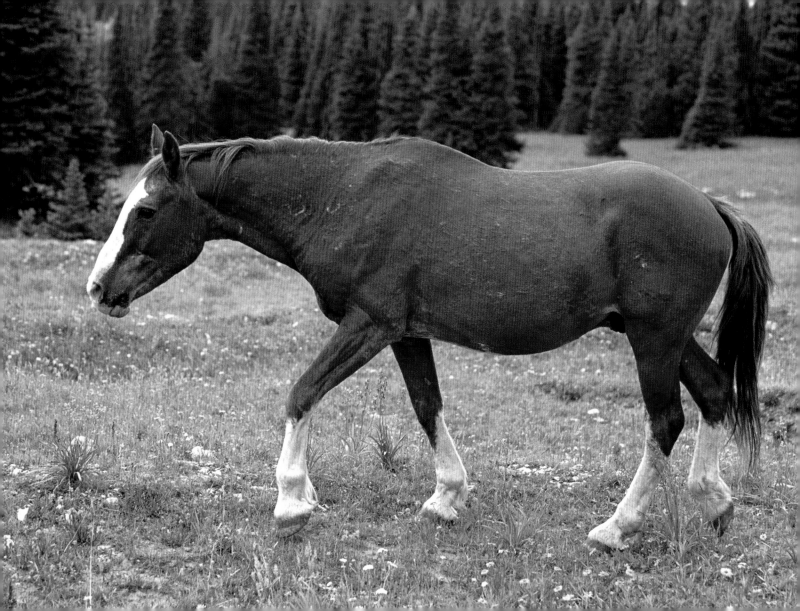

Each One a Living Legend

COUNTLESS LIVES HAVE BEGUN AND ENDED HERE, known to none but their wild companions, the mountain, the desert, and the endless, open sky. Those horses you see here represent generations of survivors and hope for an enduring future. But each year familiar faces will disappear and new foals will be born, hopefully to continue in their ancestors' hoofsteps.

Old age in the wild comes all too quickly. Even so, some of the wild Pryor Mountain horses live into their 20s. Flash (opposite) at 26 is the oldest horse on the Range. As Nature continues to shape the herd, some fare better than others, their excellent condition testifying to their outstanding natural suitability to the habitat.

Stallions: Spirit of the Wild

FEW IMAGES AROUSE MORE ROMANCE than that of the wild stallion. He epitomizes power, wisdom, loving kindness, and murderous instinct, all bound in muscle and bone. Yet even the most extravagant visions fall short of the real thing. Wild stallions are much more: complex, driven, and passionate, they are the very spirit of the wild.

The stallions you see here are as individual as any domestic horses you may have

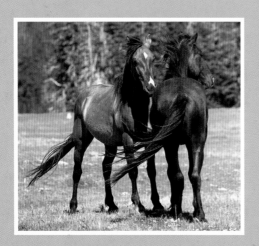

known, but unlike domestic horses their minds have not been shaped by man. They are the very essence of instinct, living in the ancient ways. Though acclimation in recent years has led them to tolerate the presence of humans — somewhat — they remain wild animals, potentially dangerous to two-legged intruders. In their own world, they are nothing short of magnificent.

◄ BACHELORS, LIKE TWO MOONS (left) and friend, depend on each other for companionship until they establish bands of their own.

▶ STALLION FIGHTS FLAIR at the peak of breeding season. Sandman (right) defends his band from the young bachelor Red Cloud, who is intent on stealing his first mare.

(preceding pages)
◄◄ NOW A SOLITARY BACHELOR OF 26, Flash was once a band sire with a thriving family. Tecumseh is his son with War Bonnet.

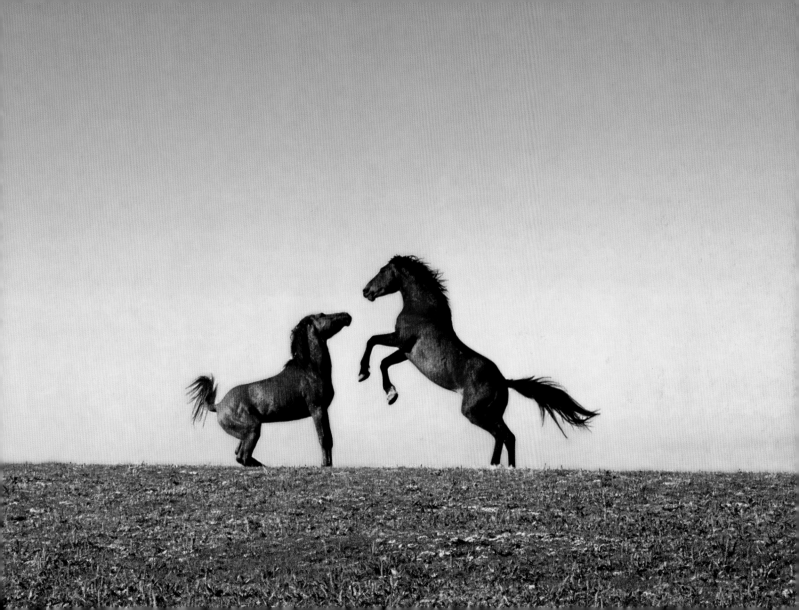

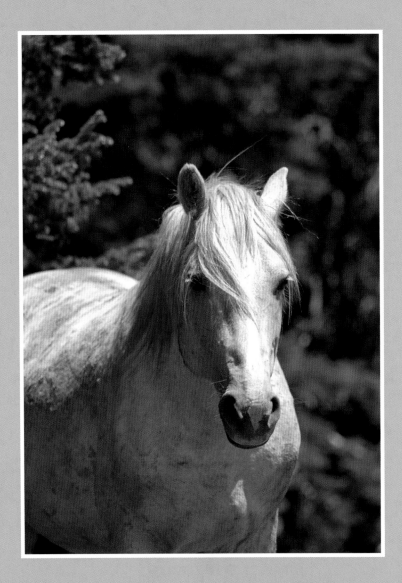

◄ A CONTENTED FAMILY MAN, Cloud has a rare color, a light palomino roan, that makes him easy to spot.

▶ HE GENTLY REPRIMANDS an errant youngster from another band and sends him home. The foal's tucked tail and mouth gestures are signs of submission.

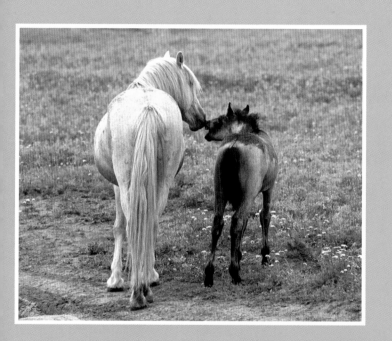

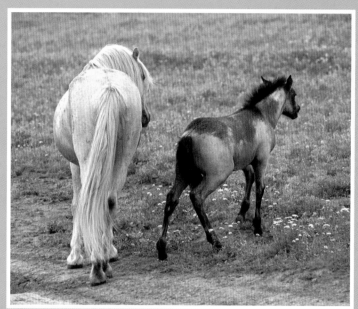

◄ A SOLITARY STALLION waits intently for an opportunity to steal a mare.

▶ IN A FURIOUS EMBRACE, Sandman (left) challenges Trigger, patriarch of the Range's largest band. Fights are as psychological as they are physical, and usually one horse backs down before severe damage is done.

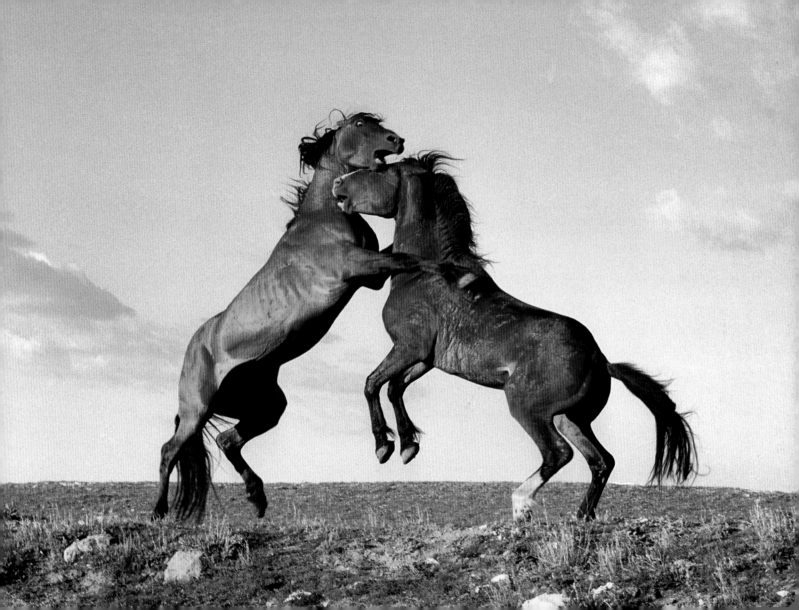

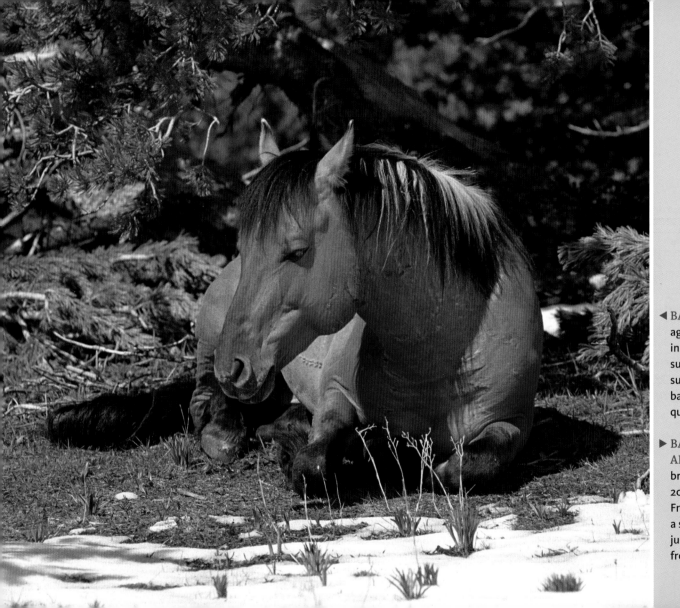

◀ BAND SIRE BAJA, age nine, rests in the mountain sunshine. Given his superb condition, battle scars heal quickly.

▶ BAJA FIRMLY ADMONISHES his brilliantly marked 2005 dun foal Freedom, named by a soldier who had just returned home from duty in Iraq.

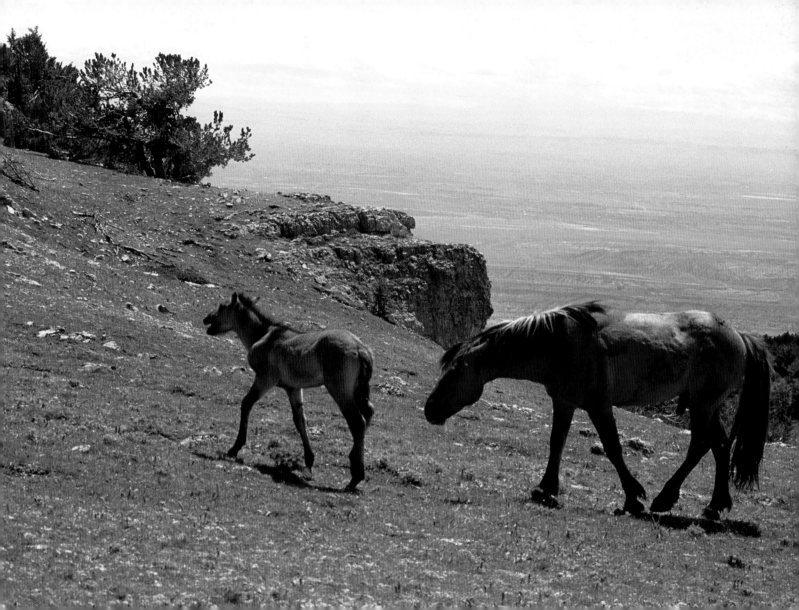

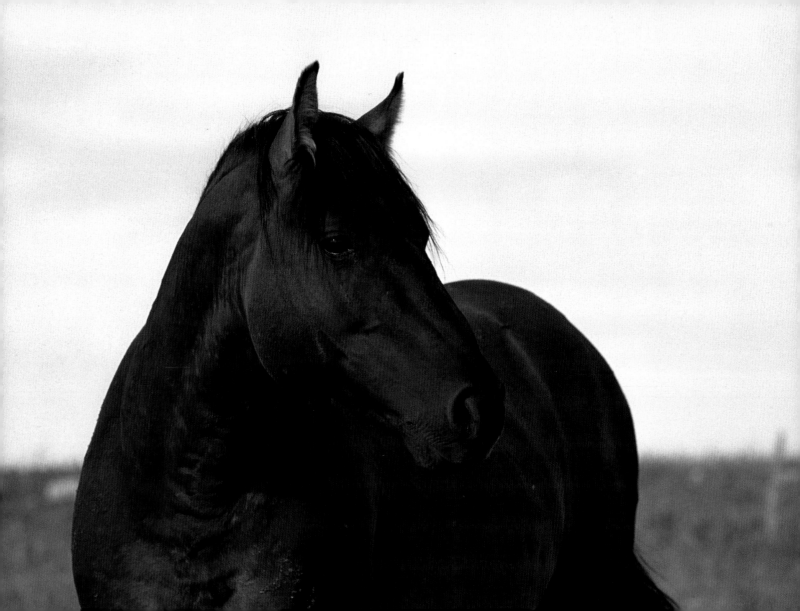

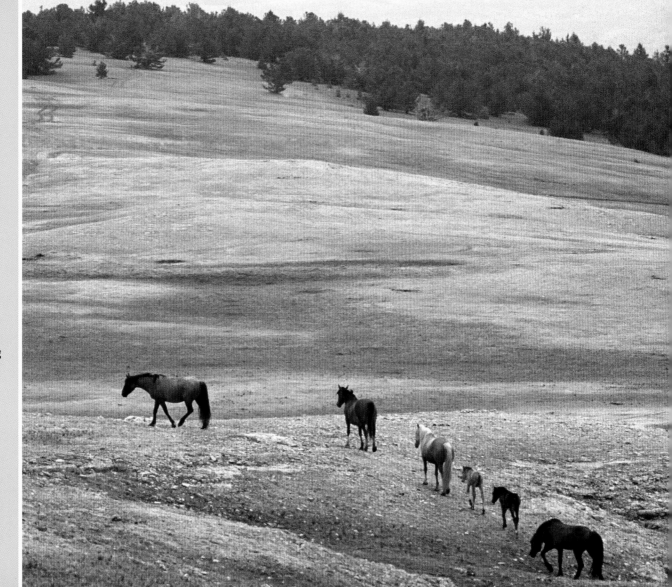

◀ **BAND SIRE LAKOTA** is known for his calm cunning as well as for his gorgeous dark grullo coloring.

▶ **WITH LOWERED HEAD,** Lakota "snakes" his band away from the restless commotion atop the mountain to find more peaceful grazing.

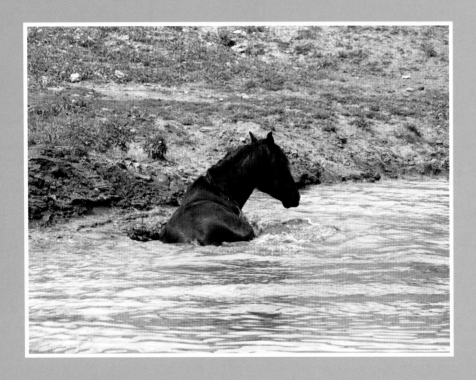

◀ AT 17, RAVEN has retreated — battered, bleeding, and beaten — down the mountain to rest and heal, after another stallion contest. Here at the water hole he recuperates. Will he ever recover his mares?

▶ LEAN AND SCARRED, young Bo has just won his first mare, and is keeping an eye on a stallion in the distance.

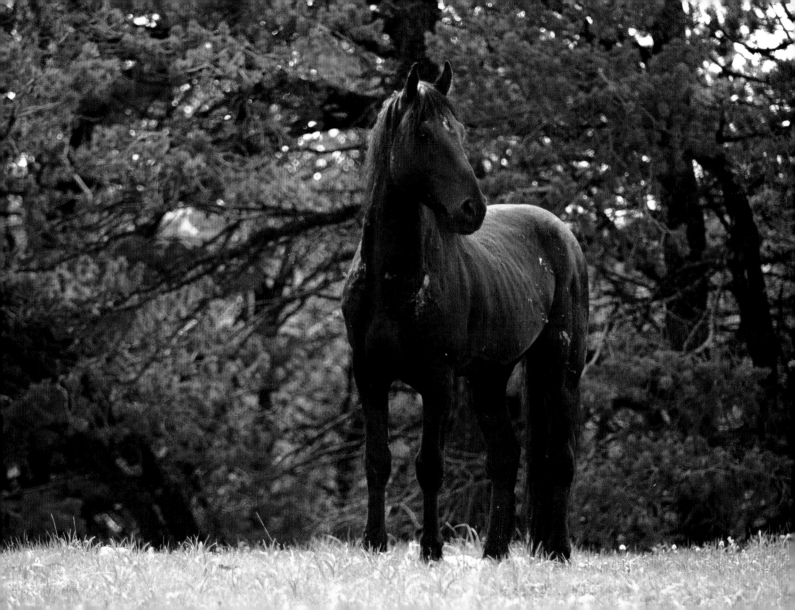

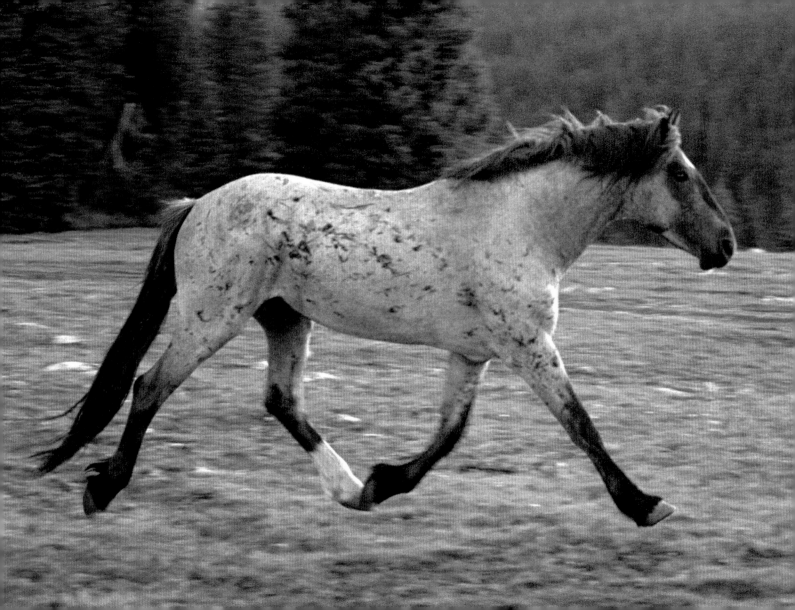

TETON, AN
ESTABLISHED
BAND SIRE,
is half-brother
to Cloud. Both
were sired by the
incomparable
Raven, for years
one of the most
dominant stallions
on the Range.

FIGHTING STYLE
DEVELOPS with
practice, according
to the individual.
Red Cloud (left)
crouches, conserving
energy, while Duke
paws the air
dramatically.

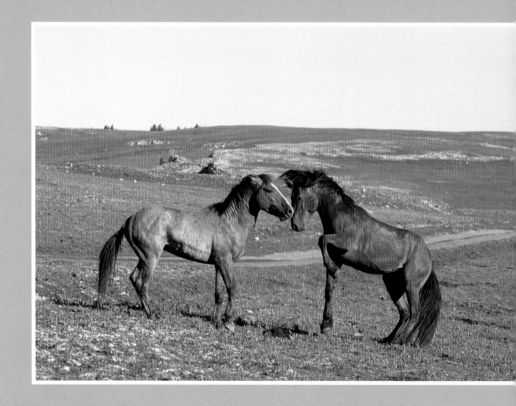

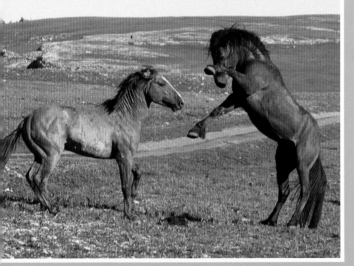

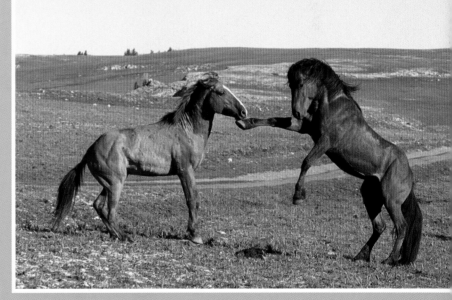

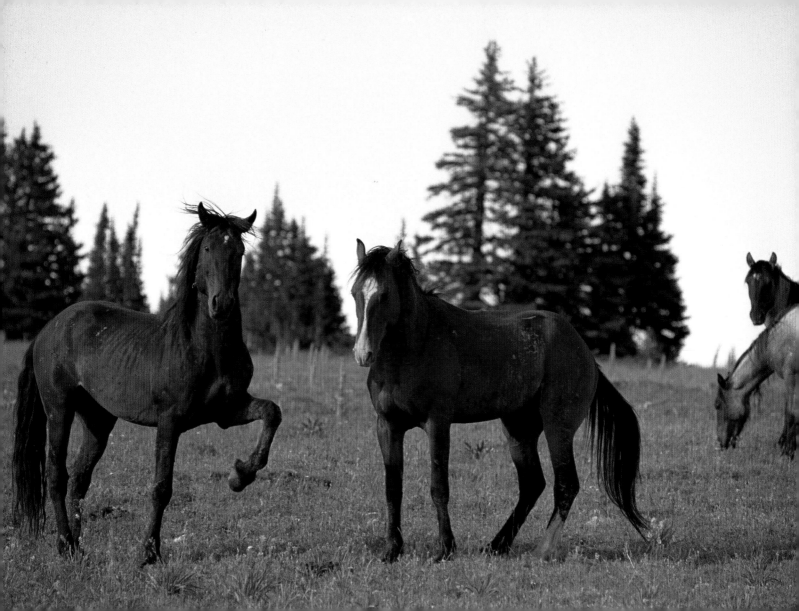

◀ SO MUCH IS
COMMUNICATED
by a gesture.
Trigger (right)
acknowledges Star's
challenge. Whether
he heeds it or not
is another story.
Mares look on, their
family structure
depending on the
outcome.

▶ BAND SIRE
CLOUD heads
back to his mares.
A "stud pile"
near the road is a
communications
center. Stallions
sniff and deposit,
staking their claims
to territory.

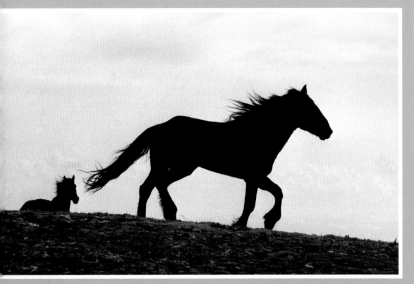 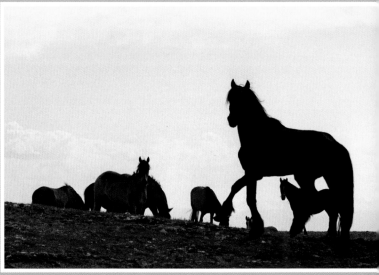

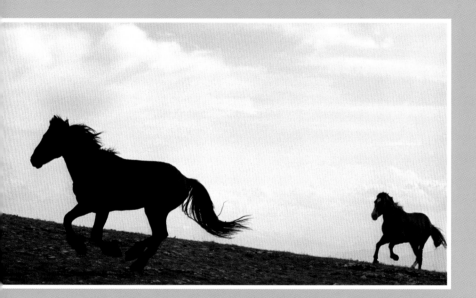

BIGFOOT DOGS TRIGGER'S BAND relentlessly, keeping as close as he dares. His left knee is badly swollen and he limps excruciatingly, but the drive to capture a mare is more powerful than pain. Further frustrating his desire, Red Cloud, a higher-ranking bachelor, runs him off repeatedly, as he too stalks Trigger's mares. Bigfoot flees on three legs, only to return and try again, and again.

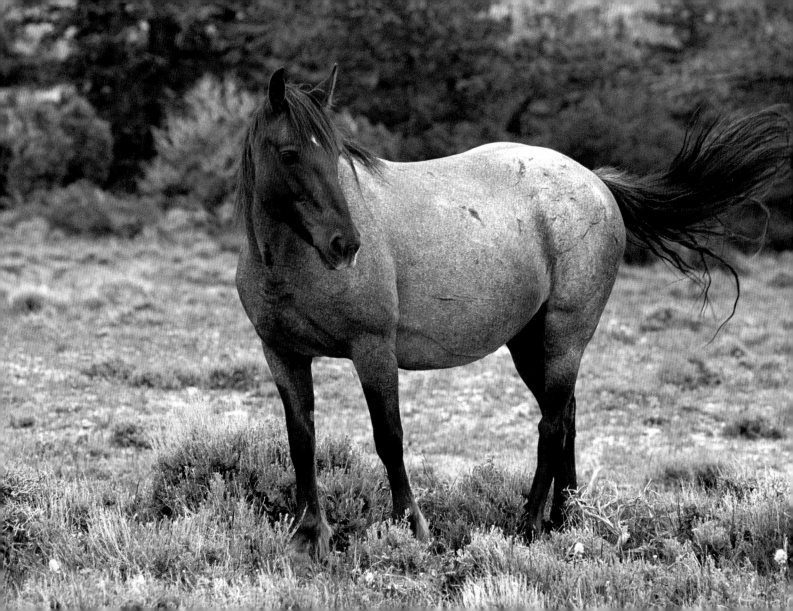

Quietly, the Mares Lead On

IF STALLIONS ARE THE SPIRIT OF WILD HORSE EXISTENCE, mares are most surely its heart. Though they may appear gentle, detached, almost peripheral, mares are as unique and opinionated as their male counterparts. They seem to know, at their core, that the decisions they make every day can be a matter of life and death. They are always alert. They hold a pecking order within the harems that only the band sire himself is above, as the mares bemusedly observe his antics.

Little alarms or deters them. They are quiet and certain. They hold the secrets of untold future generations and bear each year's new foals with hope and promise. Their role is simple: prolong the race.

CHESTNUT ROAN MARE War Bonnet at age 11.

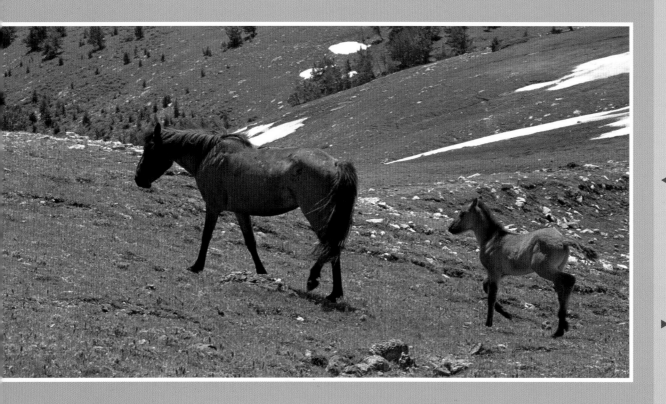

◄ **BAJA'S MARE, BACARDI,** strikes out towards water, while her foal bounces after her. Instinct tells him to stay close to his mother.

▶ **MUTUAL GROOMING** between mares (Blanca, left, and Quelle Colour) is one of the many ways in which loving, lasting bonds are forged.

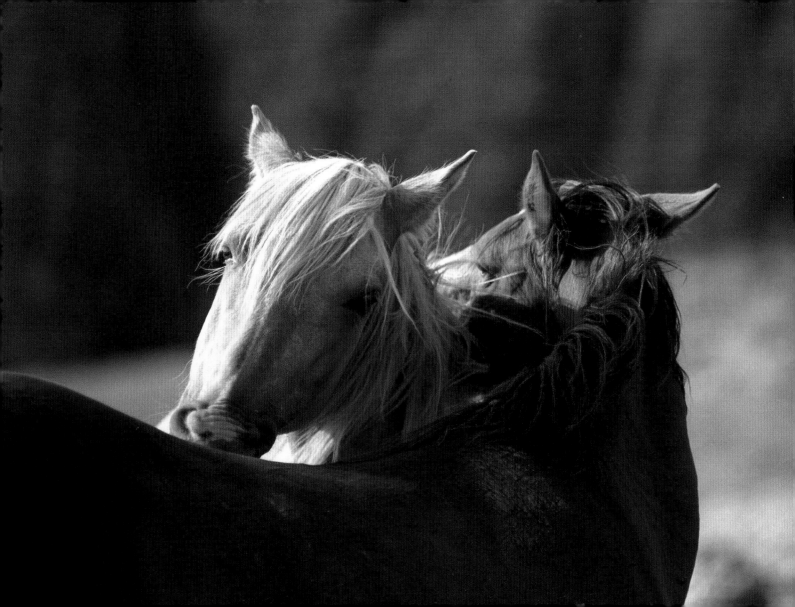

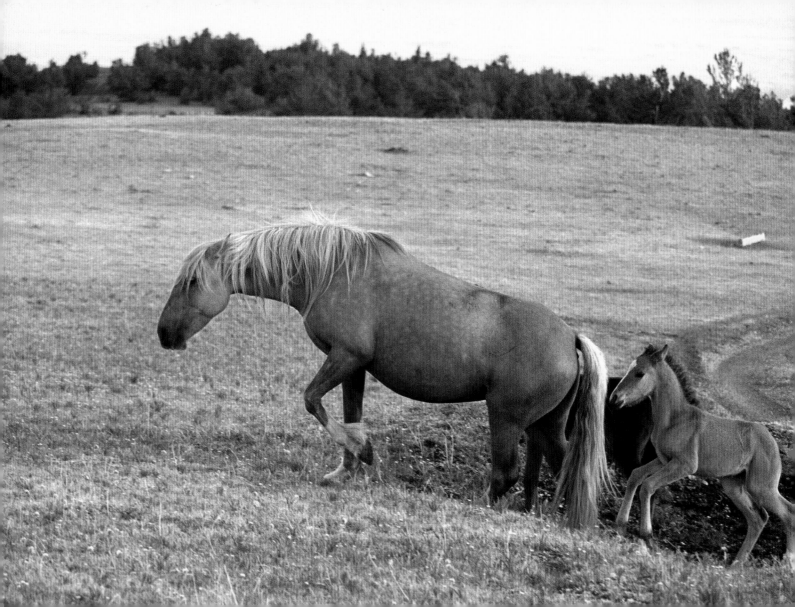

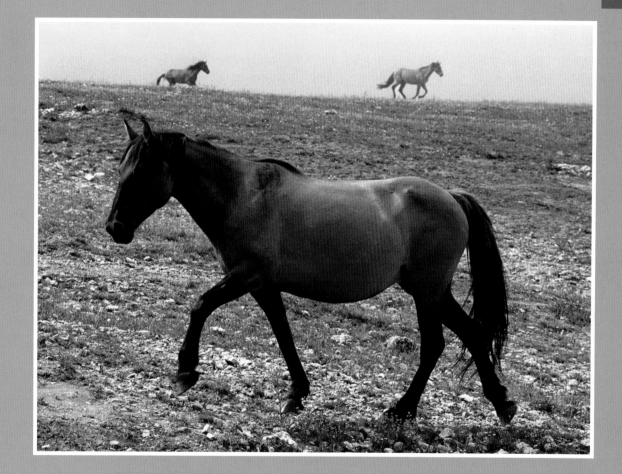

◀ DAPPLED WITH
GOOD HEALTH,
Blanca leads her
rambunctious foal.

▶ BROKEN BOW
displays dramatic
shoulder stripes.
Her hooves are kept
healthy by her daily
travels.

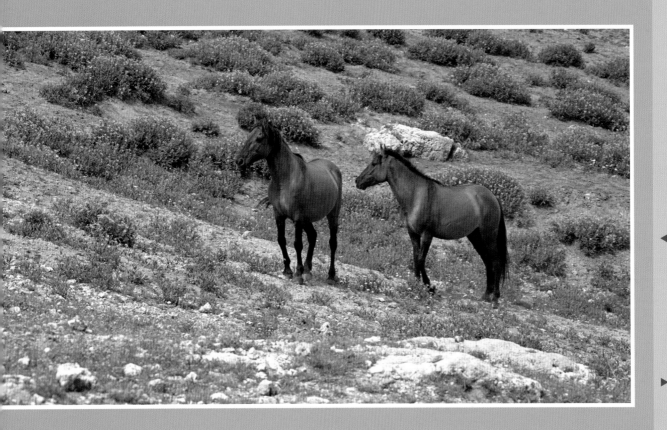

◀ COMPANIONABLE MARES Broken Bow and Demure scan the horizon. Local people and the Bureau of Land Management staff name the horses.

▶ THIS UNUSUALLY COLORED MARE'S name, Quelle Colour, could be translated as "what color?"

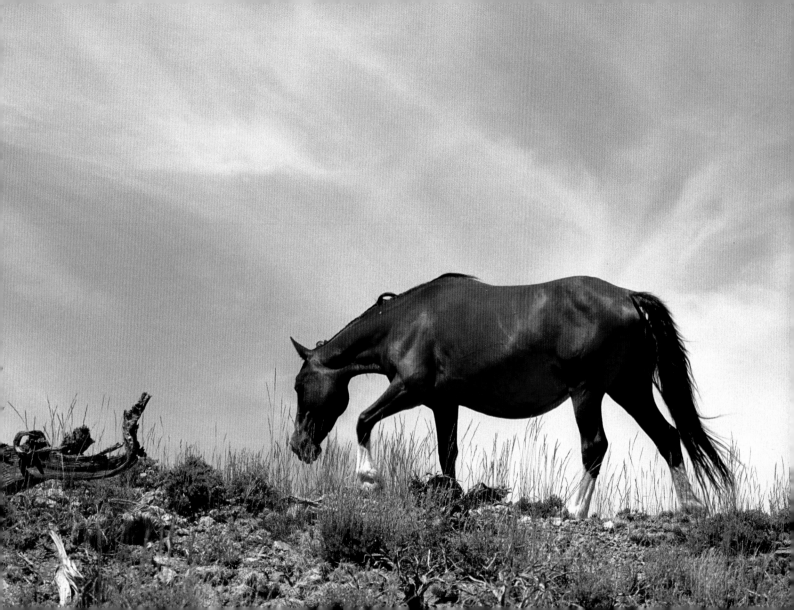

Unlike bachelor stallions, young
mares do not normally live alone in
the wild. When female foals mature,
they are taken from their mother's
band by a stallion to start their adult
lives as harem mares. They forge
strong bonds with other mares,
often remaining together when their
band stallion dies or is deposed
by another stallion.

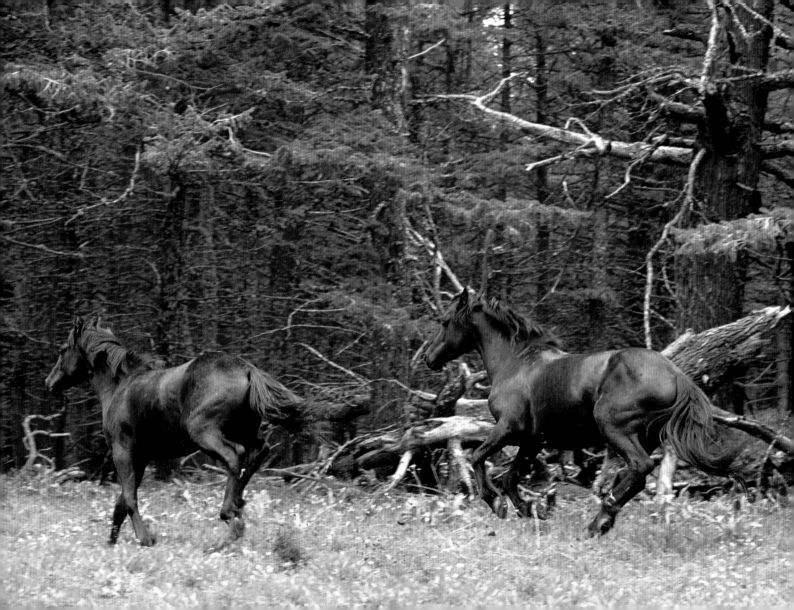

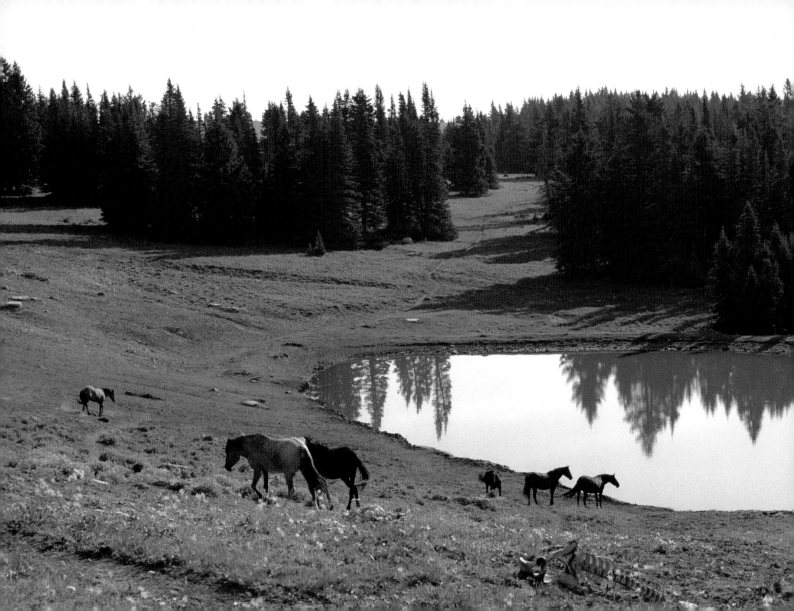

As the Days Dawn and the Seasons Change

FOR THE WILD HORSES IN THE PRYOR MOUNTAINS, daily life has changed little over the past 200 years. The whims of the weather dictate their activities just as they always have. The seasons come and go. The grass grows green, foals are born, lightning strikes, the first flakes of winter fall, old souls return to the cosmos, and it all begins anew in the spring.

Winter nearly brings life to a stop. Snow drives the mountain-dwelling horses to lower elevations and keeps those that remain on the Dry Head near the scant cover of the Bighorn River. They lower their heads and turn their backs to the constant, brutal winter wind, standing quietly for hours on end. Pawing away snow to find forage, they subsist on juniper, sage, dried weeds, bark — whatever will fill their stomachs until the first shoots of spring appear. The winter of 1978 was so severe that 75 horses died of cold and starvation, some with holes in their intestines from the roughage they had eaten.

Spring and summer arrive with a slow flush of vegetation, and the horses eat almost nonstop. Because so much of their range is barren, they cover many miles per day in search of forage. A band may be at the very top of the mountain in the afternoon and along the lower plateaus of the ridges, several miles to the south, by the next morning. They are back at the top again later that day as they repeat the timeless cycle of grazing, napping, and moving on.

Daily treks to water holes provide more than just an opportunity to drink; they are a center of family life and offer a respite from persistent insect pests in summer and early fall. As smaller water holes dry up, the horses travel to those that remain.

Autumn finds the winds reclaiming both mountain and desert with a bitter, frigid grip. The horses look for any available forage as they begin to restrict their movements to conserve precious calories.

Although intensely tracked and monitored by the Bureau of Land Management (BLM), the Pryor Mountain Mustangs are nonetheless left to their own devices for every aspect of their survival. No one comes to brush and curry. No food is provided, not even in the frozen, barren, starving depths of winter. No veterinary care is given. Such is freedom in the wild.

▶ A MARE NICKNAMED Grumpy Grulla indulges in a late-afternoon stretch. The dirt road goes through the horses' natural habitat.

(preceding pages)
◀◀ DAILY LIFE, AND DEATH itself, revolve around the water hole.

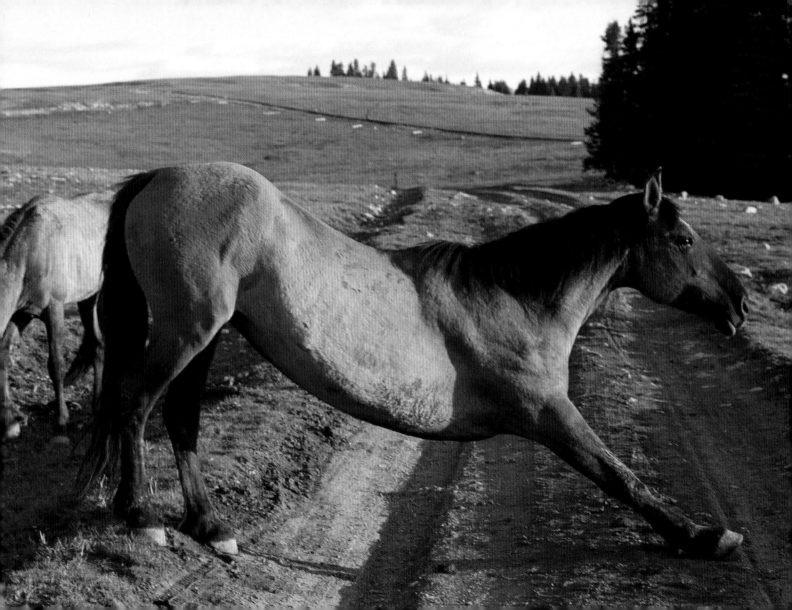

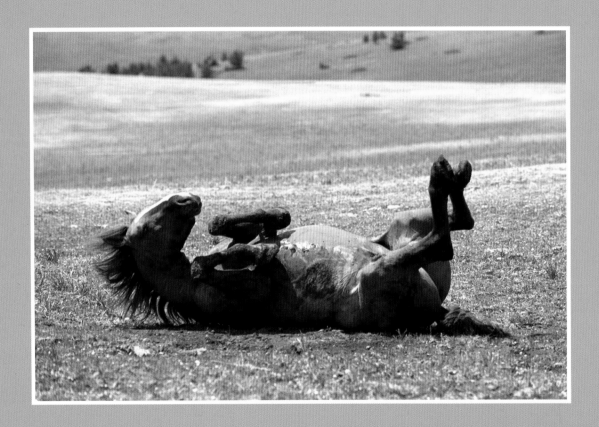

◄ RED CLOUD'S MORNING RITUAL: a good roll in the rich, red earth at the top of the mountain.

► WITH CLOUD'S BAND snoozing in the background, mares Flicka (far left), Madonna, and Atlantis (black mare) frolic in the water with bay stallion Duke.

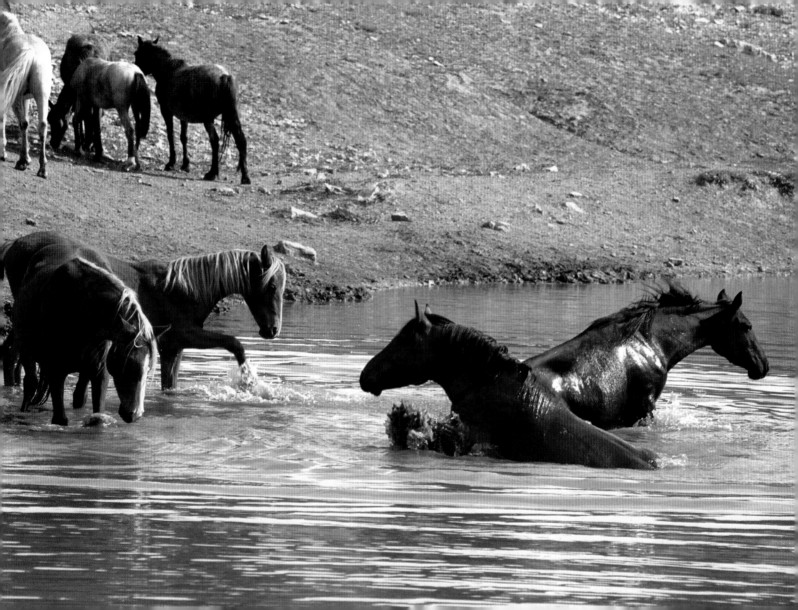

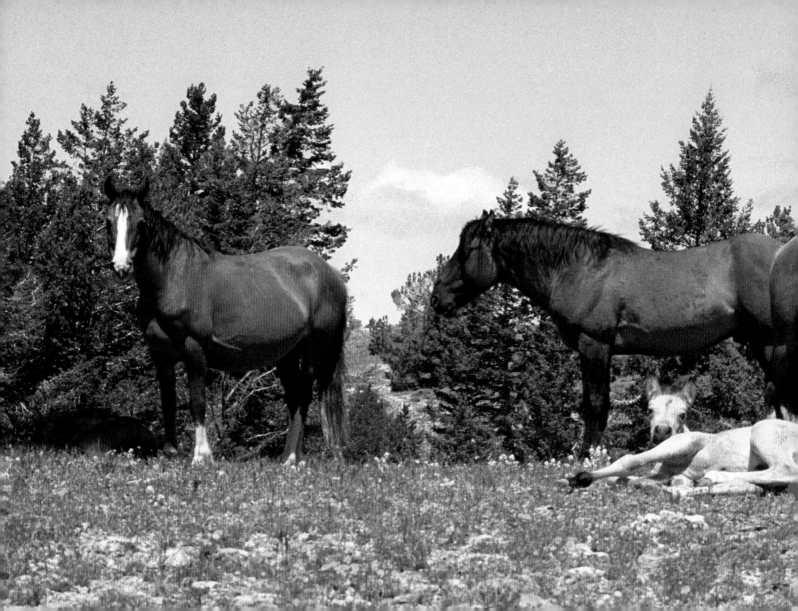

WILD HORSES FAITHFULLY guard their foals. Here, even as the band (from left: Quelle Colour, Lakota, Blanca, and War Bonnet) relaxes, at least one member is ever watchful.

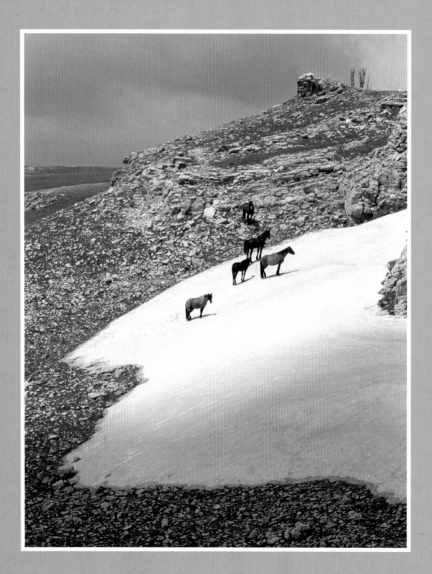

◀ HORSES SUN THEMSELVES in reflections off June's last remnants of snow. Although they sometimes eat snow for moisture, this patch feeds into an easily accessible water hole at the base of the slope.

▶ GRUNTS AND SQUEALS interrupt a calm afternoon as two stallions "discuss" the situation.

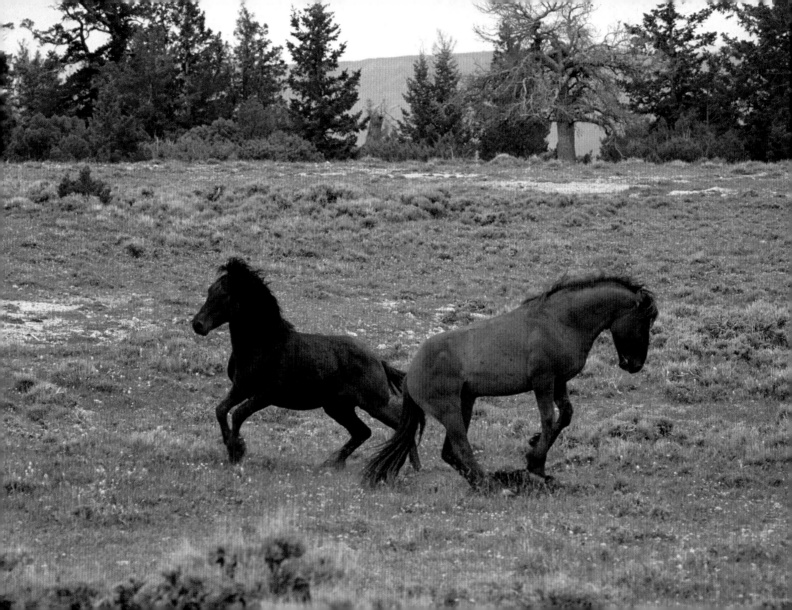

CUSTER (LEFT), A BAY ROAN STALLION, and his mare, Waif, savor the morning sunshine and each other's company. Centuries ago, buffalo created dirt wallows at the top of the mountain, enjoyed ever since by livestock and wild horses alike. Moles have freshly churned the soil, affording this pair of mustangs an invigorating June dust bath.

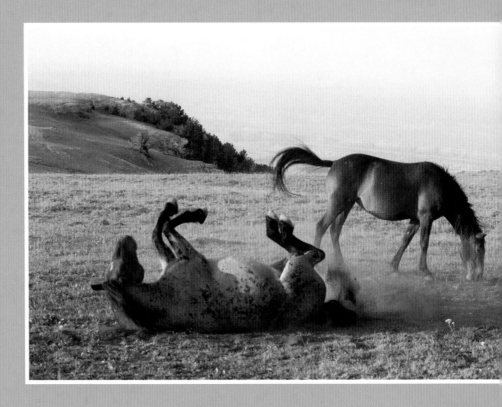

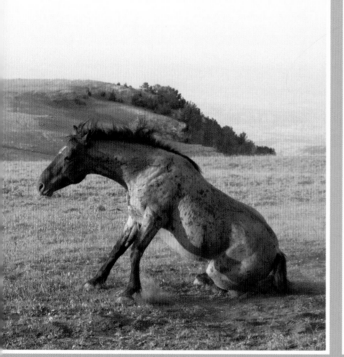

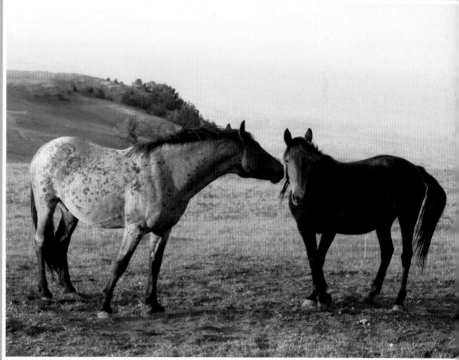

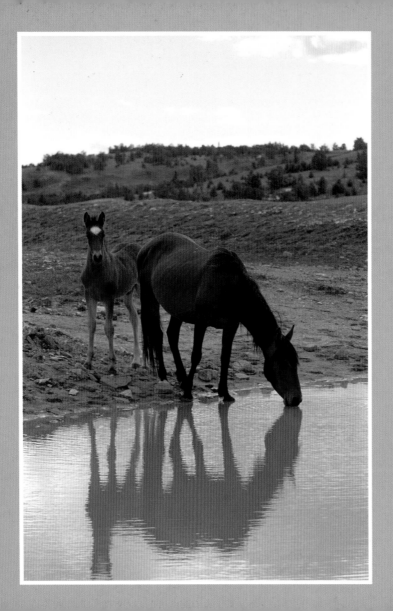

◀ CUSTER'S MARE, WAIF, and her 2005 foal enjoy their turn at the water. On the Range, horses generally visit the water hole only once a day.

▶ REST IS AS IMPORTANT as activity in the wild. Lakota's band relaxes in the open where approaching intruders are easily spotted.

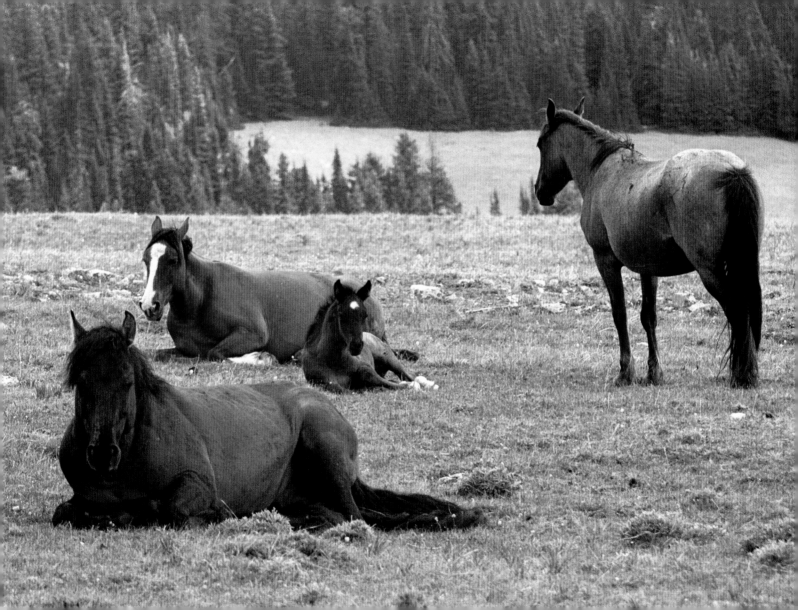

"The whole country around was
overrun with thousands
of homesteader's horses . . .
but this little band was not of this
class. They were, and are, the genuine
little Spanish horses and there
were about 70 head. I did not try to
get them and hoped that no one else
ever would and that if a try was
made it would fail. . . ."

— *From a letter by Charles O. Williamson, lead investigator of trespass horses in the Pryor District until 1929*

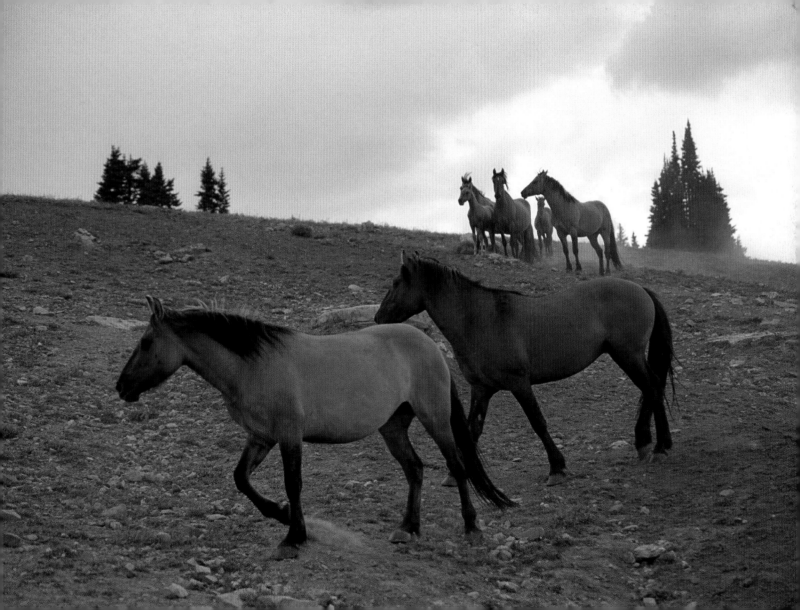

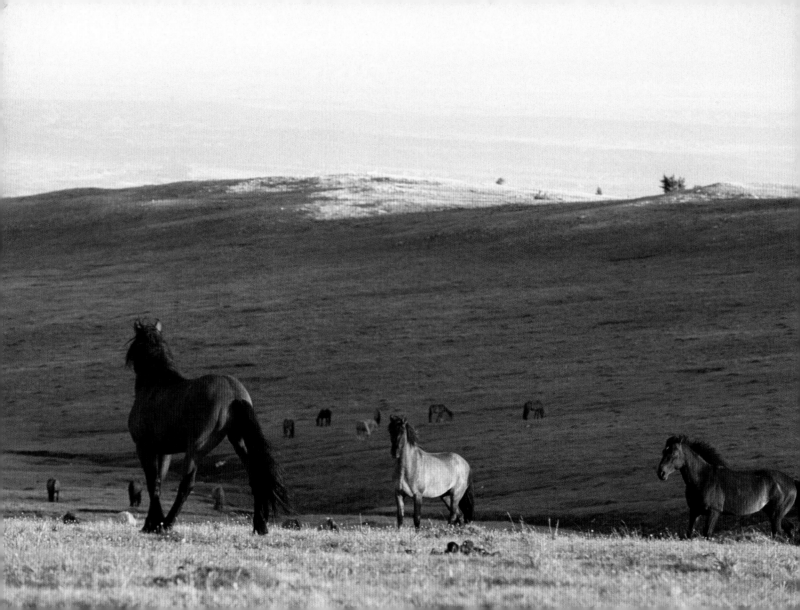

They Speak without Words

THE HERD IS AT ONCE A COLLECTION OF UNIQUE INDIVIDUALS and a single wild entity. It depends as much on the interaction among the horses as on the heartless landscape they inhabit. Their relationships and social order are vital to their survival.

The herd is made up of small, intimate family units called bands. These may be just a stallion/mare couple or a larger extended family with many mares (the harem) and foals, yearlings, two-year-olds, and even older offspring. Bands are not always stable, as stallions are always eager to claim mares from their brothers. Fillies leave their home band with a marauding stallion in about their third year, and colts are driven off by the

band sire, usually between the ages of two and four. When young stallions are allowed to stay with their home band they serve as a second in command and may even be allowed breeding privileges.

Stallions that roam the same territories here have known one another all of their lives. Relationships formed as foals may buy some tolerance in adulthood. Bands often graze near one another, and the stallions seem to be unconcerned but always keep an ear or eye aimed in the other's direction. Even so, in the late spring and summer much of a stallion's energy is exhausted in protecting his mares, or in the unceasing effort to claim one (or more).

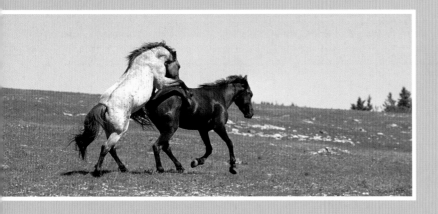

Battles can be violent, but it is the constant state of guardedness, and the lack of food and sleep, that wear down the most anxious. Band sires may work together to chase bold, hormone-crazed

◄ **FLINT, NOW A FOUR-YEAR-OLD** stepson to Cloud, is still a member of his band. Although Cloud allowed it, young mare, Bailey, vetoes the younger stallion's attempt at breeding privileges.

(preceding pages)
◄◄ **WHEN BANDS COME TOGETHER** to graze on the lush summer grass at the top of the mountain, band sires and bachelors alike are on guard. Confrontations are common during breeding season.

young stallions from their midst. Those like the wise and wary Lakota live a life of ease compared to the lean, electrified Sandman. When a stallion does steal a mare, whether she goes willingly or not, the stampeding rush of capture can be traumatic. Foals may be crushed underfoot as they huddle near their mothers.

Each band has a lead mare, although she may not be the most dominant. The lead mare is trusted and followed; often she will lead the band from one site to the next, with the stallion trailing along behind. In contrast, a dominant mare will assert first dibs at the watering hole, a mud wallow, or a patch of grass, but she may not be the one her band mates follow. Unlike in other wild herds, the Pryor Mountain stallions are just as apt to gather their harems and head them in a direction of their own choosing as they are to follow their lead mare. Just as there is a hierarchy within the bands, there is an order among them, with more dominant stallions commanding the more dominant bands. Dominant bands graze first, drink first, and proceed unobstructed.

Communication among these horses is constant and clear, but rarely verbal. Mares nicker to their foals, and stallions shriek in rage; but more often the message is as subtle as the flick of an ear or the tilt of a head.

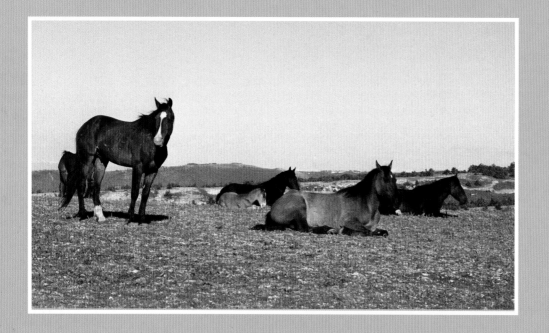

◄ WATCHFUL
BAND SIRE Trigger
stands sentry while
his harem rests,
knowing he will alert
them if need be.

► TWO STALLIONS
TUSSLE, with
the vast Wyoming
desert unfolding
in the distance.
Natural and man-
made boundaries
have created an
island-like habitat,
which both confines
and isolates the
horses.

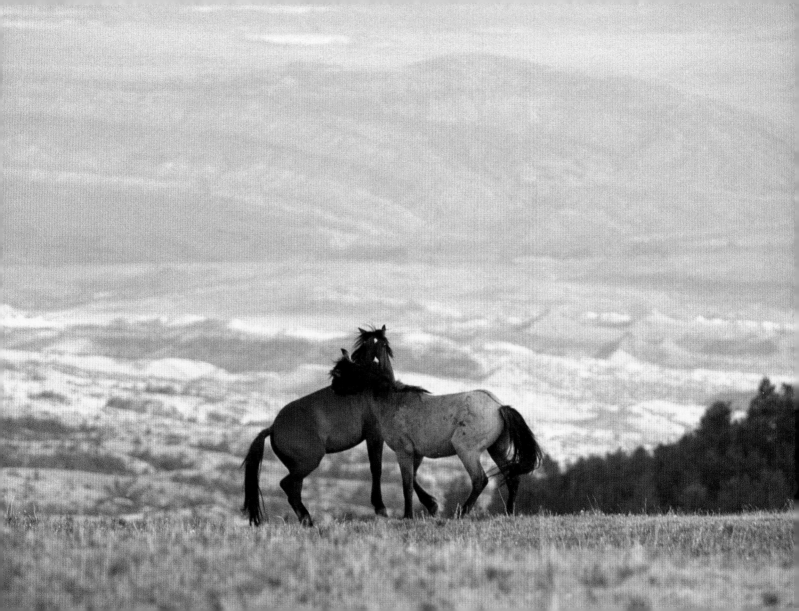

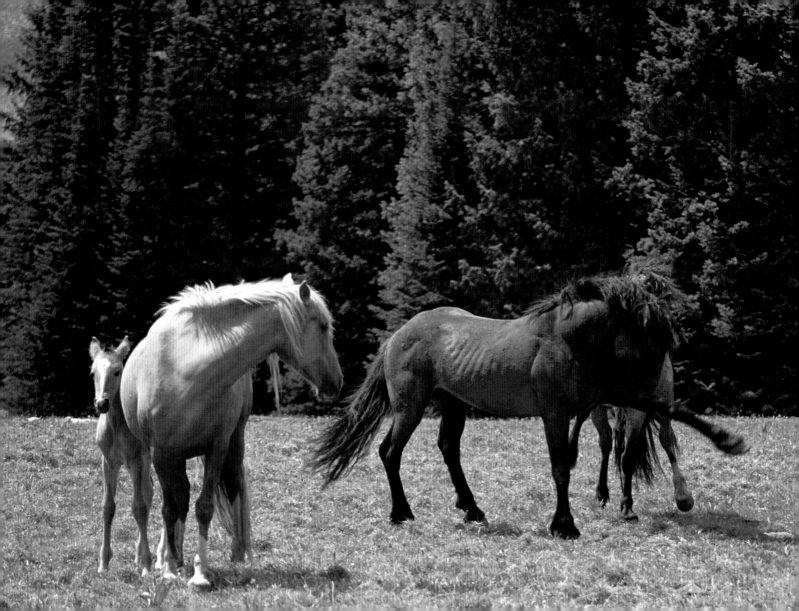

◀ LAKOTA, USUALLY SERENE and seemingly gentle, doesn't hesitate to bar another stallion from getting too close to his family. Blanca seems unconcerned, but her foal nervously clings to her side.

▶ STALLION CONFRONTATIONS are a part of life, but so too is harmony. Here, Cloud's and Lakota's bands partake together.

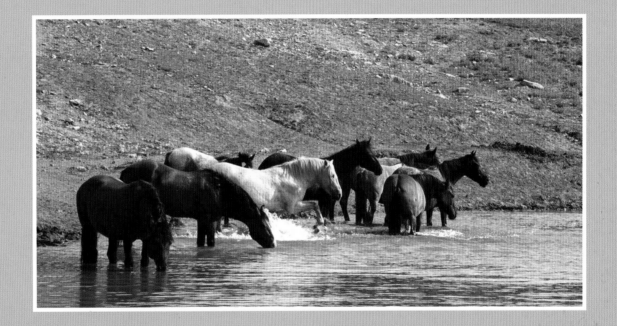

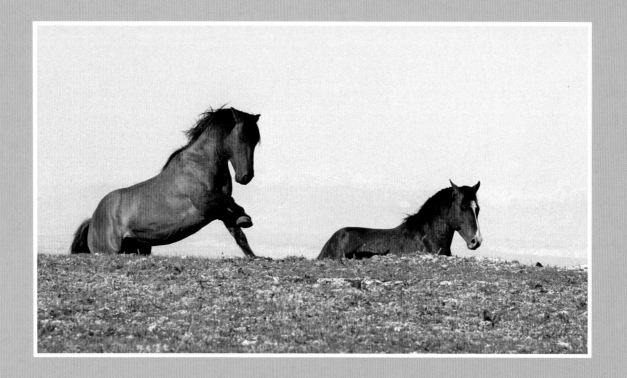

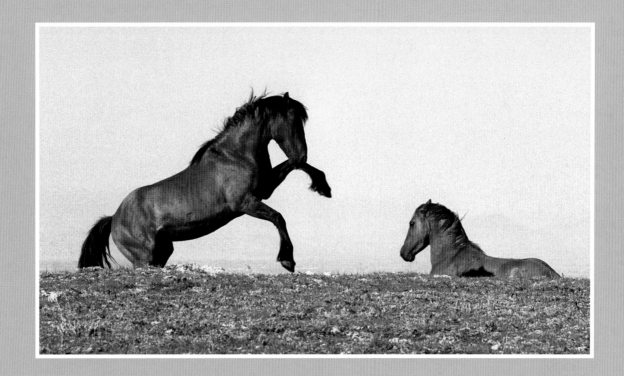

AT 19 YEARS
OF AGE, Shaman
demonstrates the
prowess that keeps
him the oldest
band stallion on the
Range. He wards
off any stallion that
approaches his
band, first Trigger
(left), then the ever-
challenging Red
Cloud (right).

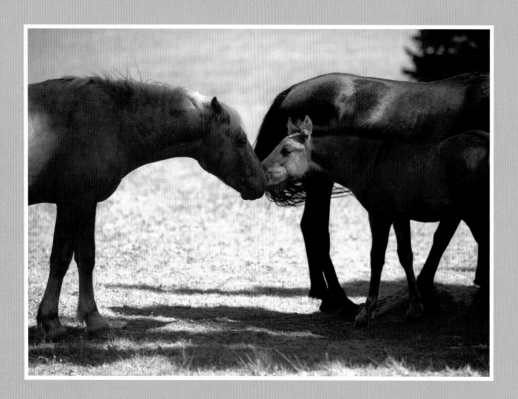

◄ A STALLION'S LIFE knows many phases, from foal to young stallion within a band, to lonely outcast, to band sire, and back to bachelorhood. At left, Bolder warmly acknowledges a youngster from his band.

► OFTEN SEEN GAZING over the same ridge, Tecumseh, now seven years old, is just starting to challenge other stallions for a mare of his own. Will this be his year?

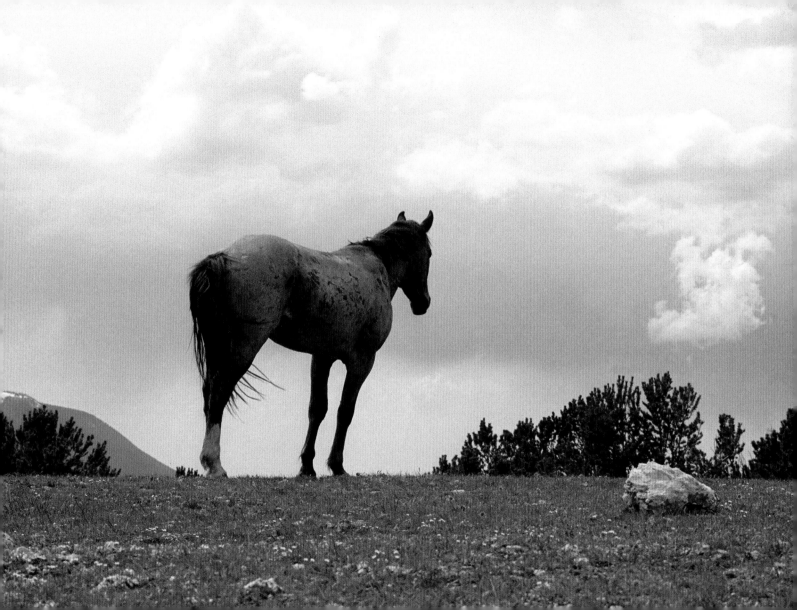

A COMMON SCENE at the peak of breeding season, as stallions try to gain more mares. Here Sandman goes after one of Trigger's mares and meets strong opposition. The little roan mare, BJ Star, quickly gets out of the way.

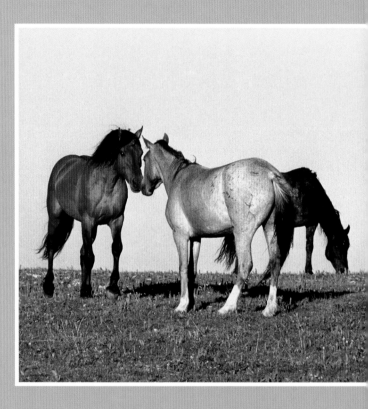

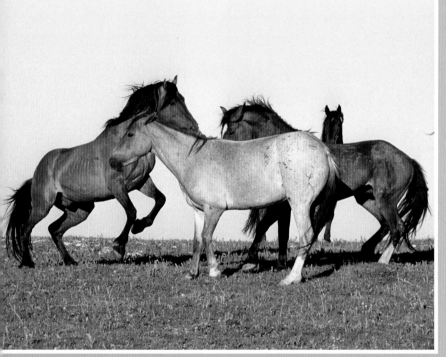

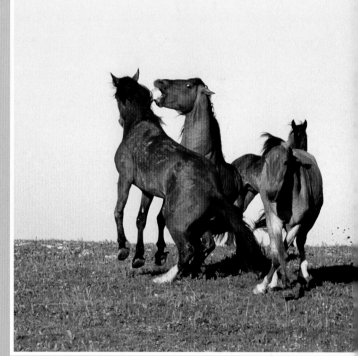

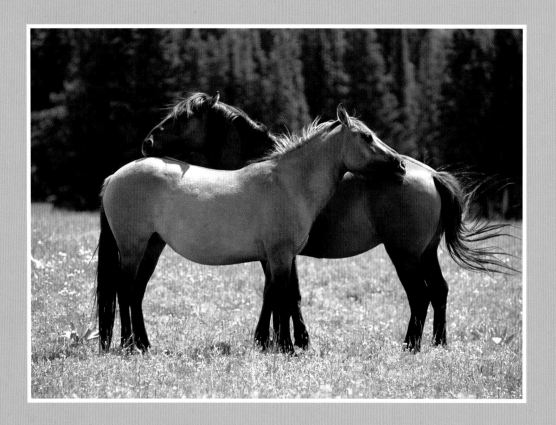

◀ IN A MOMENT OF QUIET DEVOTION, Brumby and Jackson display one of the many emotions of wild horses.

▶ TRUE FREEDOM for wild horses is following their own social instincts. Dominant bands drink first and then sun themselves while others take their turn.

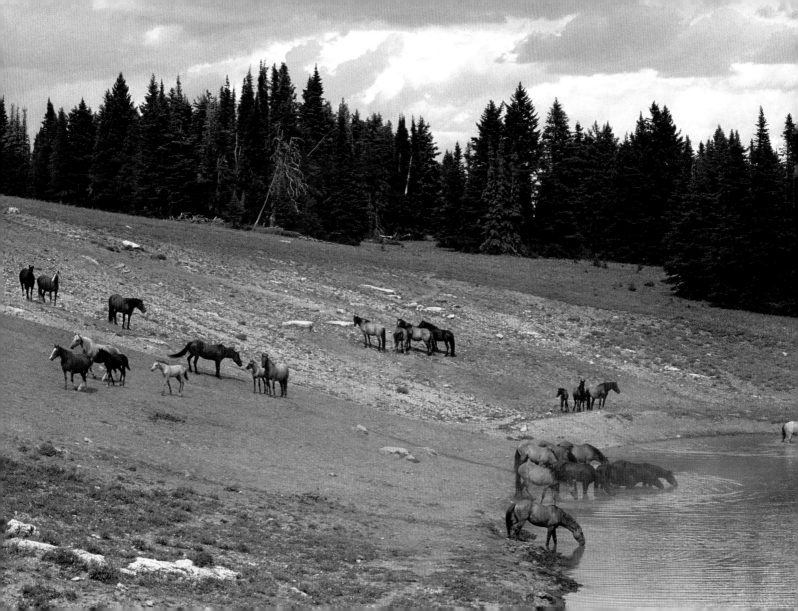

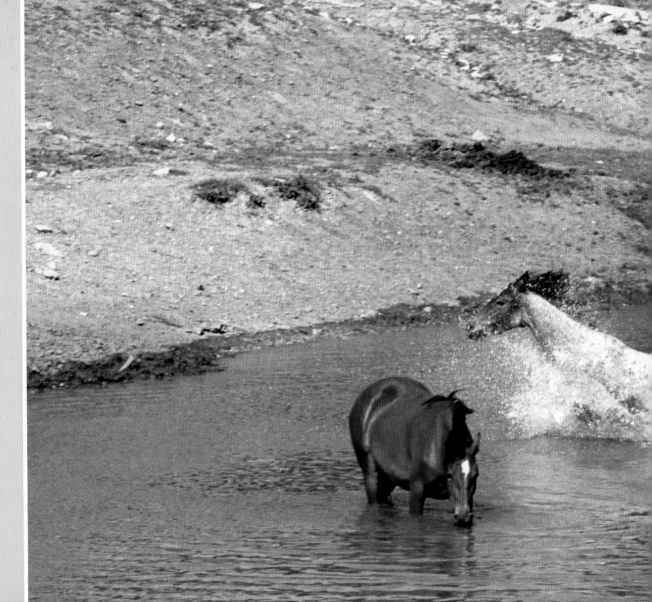

SENSING DANGER or an approaching intruder, Morning Star's band erupts in a sudden flurry, abruptly departing the water hole.

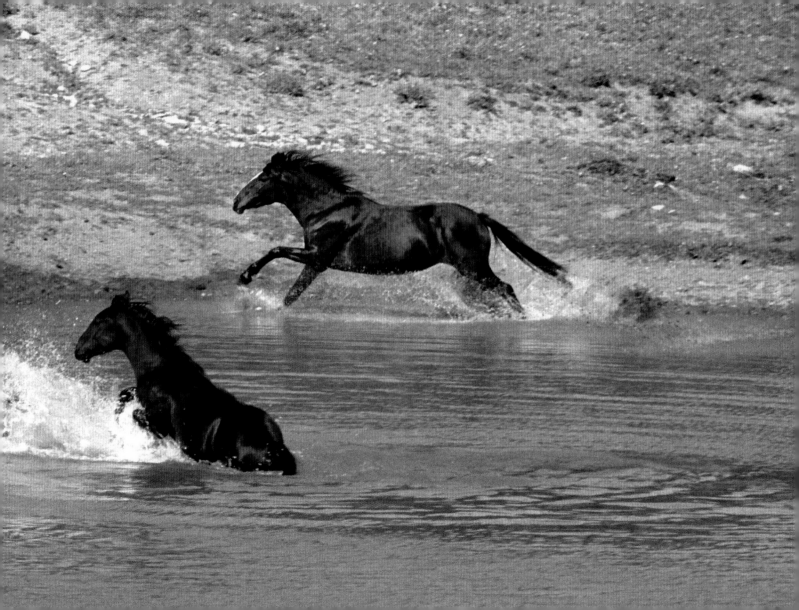

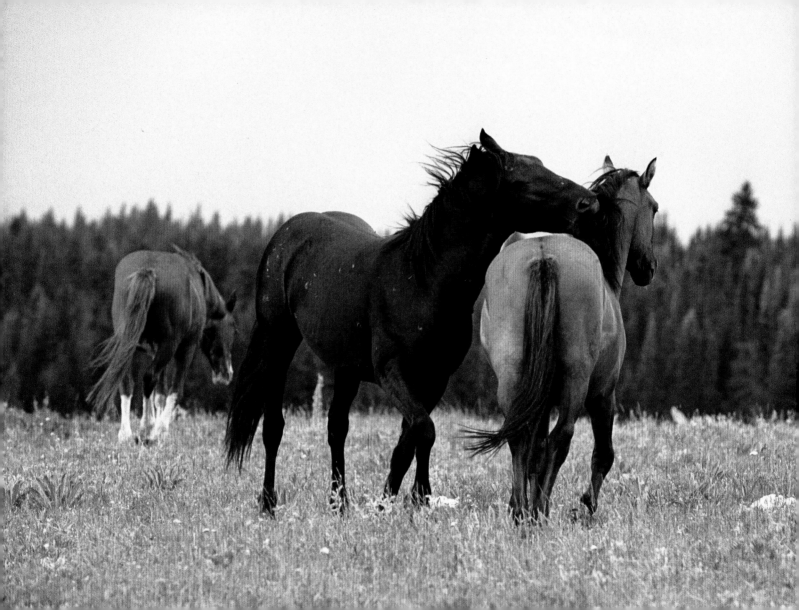

◀ **TWO YOUNG BACHELORS** "horse around" as Flash, 26, the oldest horse on the Range, meanders off. His fighting days long behind him, he visits other bachelors occasionally for companionship but spends much of his time alone.

▶ **FATHER KNOWS BEST.** Band sire Santa Fe bears down aggressively on Doc, a two-year-old stallion from his band. It may take days for Santa Fe to drive the reluctant youngster away, but the time has come for Doc to live on his own.

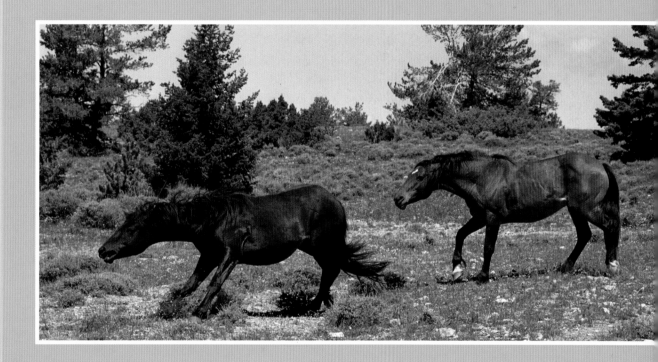

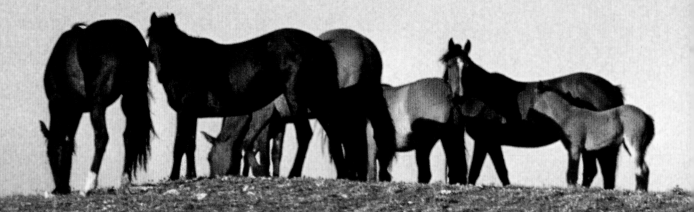

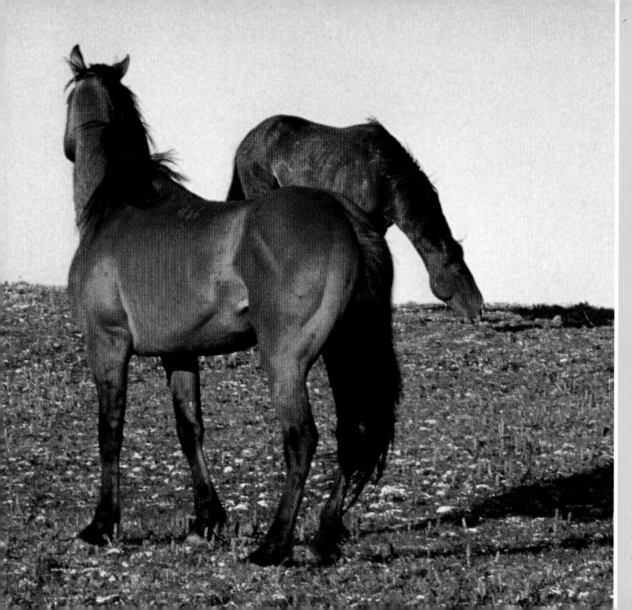

EARS FLATTENED, HEAD LOWERED, band sire Trigger gestures a warning to the ambitious Sandman to "back off." Sandman, who has left his own mares in search of more, has one eye (and ear!) on Trigger, the other on the mares.

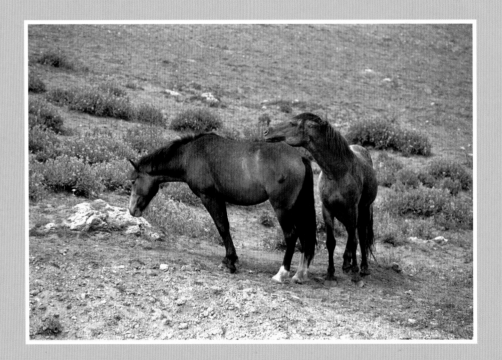

SOMETIMES
LOVE IS IN THE
AIR, sometimes
it isn't. Mescelero
fondly caresses a
contented Dove
(left), while a young
roan stallion has
his hopes dashed
(right).

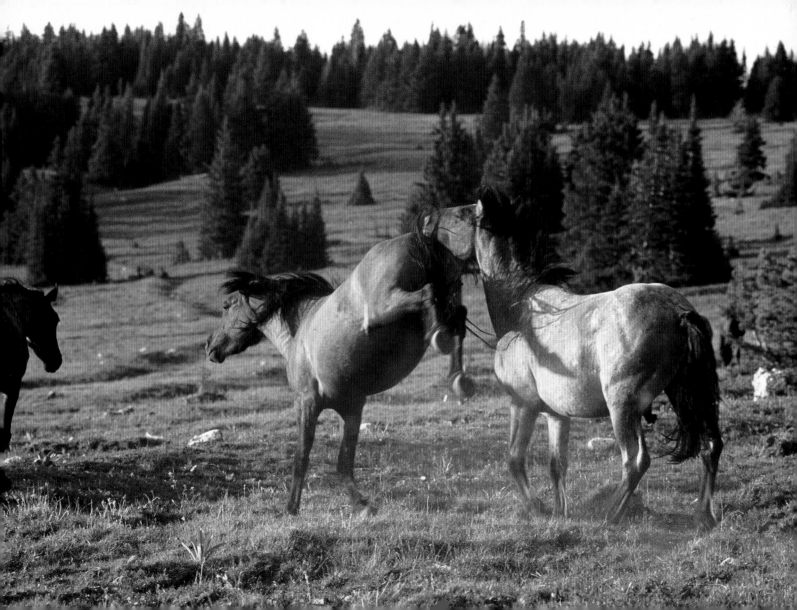

"Congress finds and declares that wild free-roaming horses and burros are living symbols of the historic and pioneer spirit of the West; that they contribute to the diversity of life forms within the Nation and enrich the lives of the American people and that these horses and burros are fast disappearing from the American scene. It is the policy of Congress that wild free-roaming horses and burros shall be protected from capture, branding, harassment, or death; and to accomplish this they are to be considered in the area where presently found, as an integral art of the natural system of the public lands."

— *Wild Free-Roaming Horses and Burros Act.*
Congressional Decree Pub. L. No. 92-195, 1, 85 Stat. 649
(December 15, 1971)

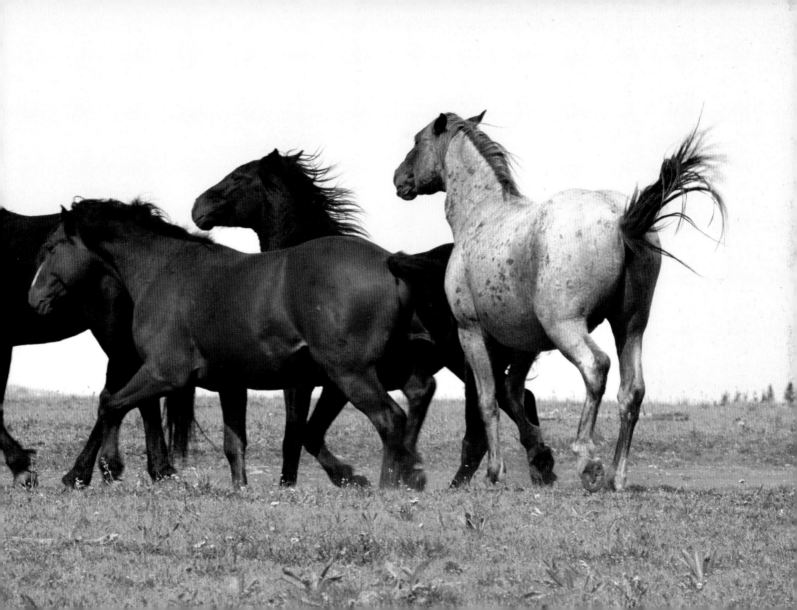

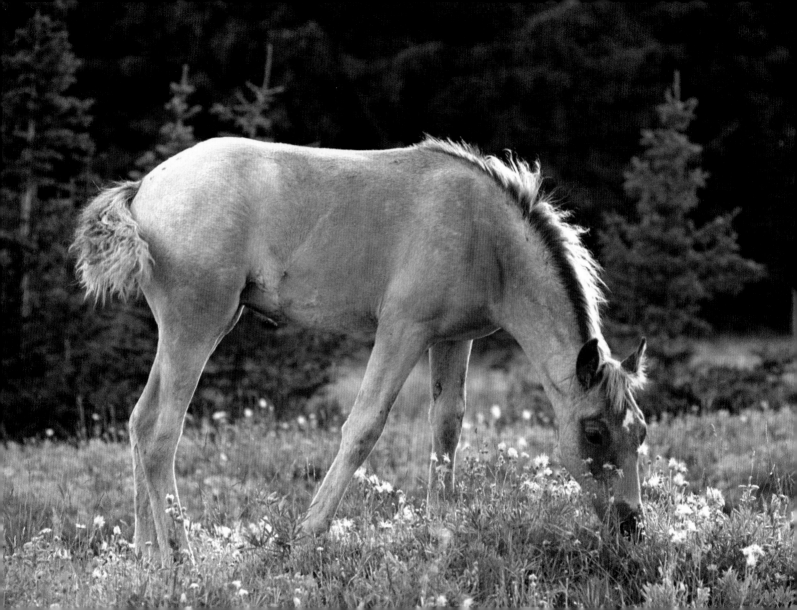

The Legacy Continues

FOR EACH YOUNG STALLION THE SOLE GOAL IN LIFE is to establish a harem and father a new generation. In other herds this is often accomplished at five or six years old, but it can be more difficult in the Pryor Mountains. Although mares in the wild usually outnumber stallions, often by three or four to one, here management practices leave more stallions than mares. While, in theory, this may encourage genetic diversity, it reduces the odds of any one stallion finding, or keeping, a mare.

To acquire a mare of his own, a young stallion must steal one from a band sire. Stealing a daughter old enough to leave the band is hard enough, as the band sire will jealously protect her, but stealing a breeding mare can be even more difficult and dangerous. After trailing a band for hours — or days — the bachelor makes his move, often waiting until the band sire seems inattentive. He may move in between the mare and her band mates, maneuvering her, then snake his head low and chase her away from her companions. Her sisters may call out. The band sire will certainly attack, charging in blind rage at the intruder. His instinctive need is stronger than pain, hunger, or fear.

The same scenario plays out even with established band sires that leave their mares unattended while they try to acquire one more. And often, the absence of a band sire is just the opportunity another stallion needs to raid the wanderer's harem.

Late May through July is the height of both the foaling and breeding season in the Pryors. Most foals are born in this period, and within a month of a foal's birth its mother comes back into estrus. Stallions' nerves are frazzled and skirmishes are common. Mares foal unaided, and within minutes most foals are up and nursing, ready to test shaky legs. Foals grow bolder as they grow stronger, exploring the world around them.

Not all mares bear foals. Sometimes they fail to conceive naturally, a few miscarry, and many are darted with PZP, a contraceptive. Since 2001, those deemed too young to bear foals have been treated with PZP until they are more mature. Most recently, all mares 11 years and older are also treated.

To keep the number of horses down, the BLM has traditionally held "removals," in which horses are captured, corralled, and detained, then shipped off for adoption. Hopefully, fewer births will relegate these roundups to nothing but dusty memories or at least reduce their frequency.

▶ FOALS GET WISE to the social hierarchy early in life and begin to assert themselves. Cloud's foals nudge away a visitor.

(preceding pages)
◀◀ CLOUD'S HEALTHY 2005 FILLY has grown strong by mid-August. Mares ovulate in spring and summer, which prevents foals from being born in winter.

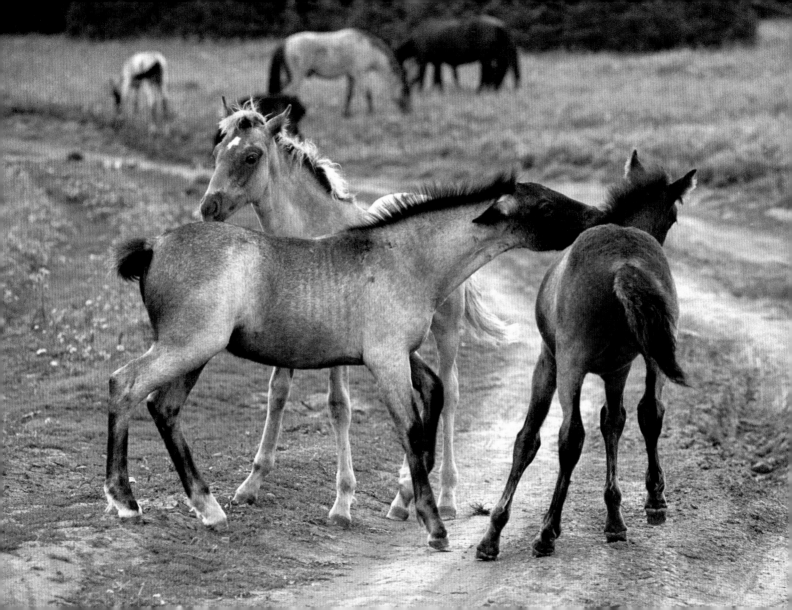

Young stallions, ousted from their family bands, often join together in bachelor bands for the security of companionship. They playfully tussle and spar, honing their skills. Friendly now, in the future band mates may collide in more perilous bouts.

Once he acquires mares, a stallion may preside over a harem for ten years or more, but eventually a younger, stronger, faster stallion will defeat even the most dominant sire in the herd. Some never recover from this. Others wander the mountain in solitude, or follow the band near its fringes, settling for glimpses of the family life they once knew.

Death stays near the youngest and the oldest. In 2004 all but one foal was lost, most likely to cougar predation. Foals routinely die of unknown causes. Entire bands have been incinerated by sudden lightning. Horses have disappeared over high, rocky cliffs. During drought and blizzards horses die of starvation. Injuries kill either through infection or by weakening the horse for predators. And always, the old succumb to time: 16 to 17 years here is a lifetime for most.

◄ A FOAL FROM CONQUISTADOR'S band browses along the lush western edge of the Pryor Mountains, which falls under Forest Service management.

► LIVING NEAR THE SCRUBLAND, this mare and foal are often exposed to high winds, bitter cold, drying sun, and drenching rains.

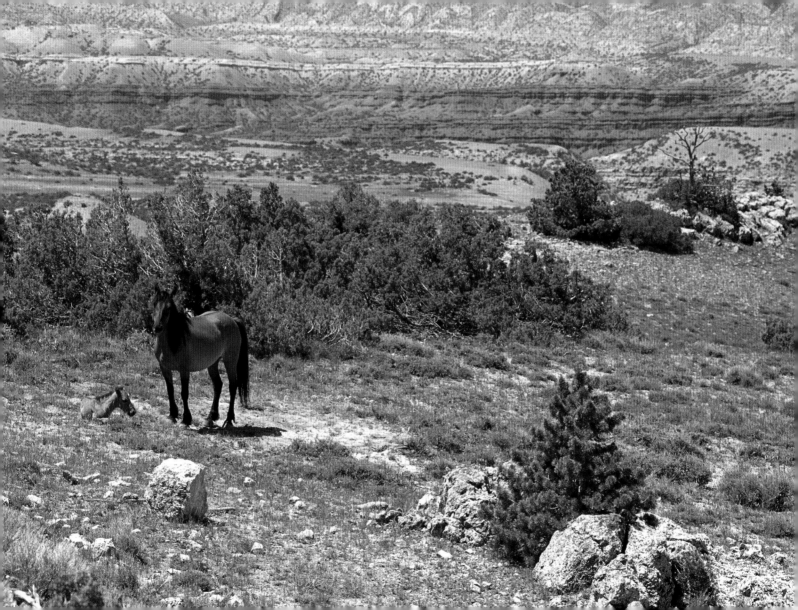

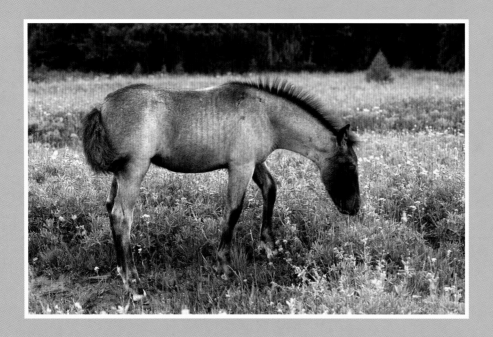

◀ FOALS DEVELOP INSTINCTS and good sense in the wild. Curiosity can be costly, but learning which plants taste best always pays off.

▶ THE EQUINE DRIVE FOR COMPANIONSHIP is so strong that odd alliances are not uncommon. A mature bachelor has teamed up with a yearling.

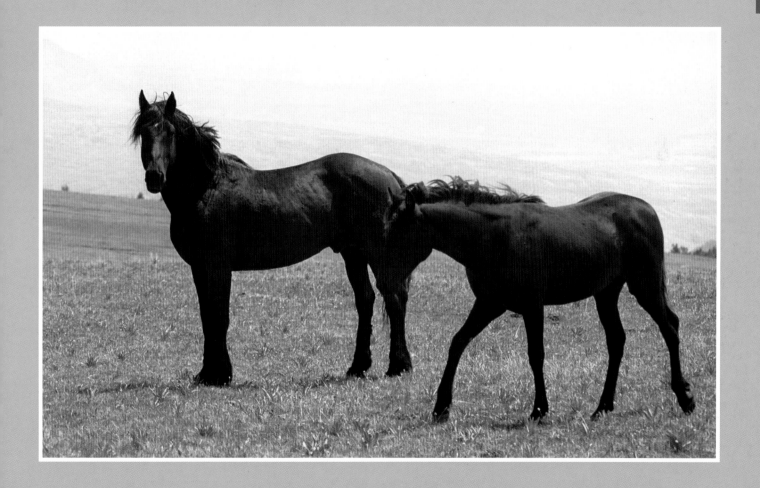

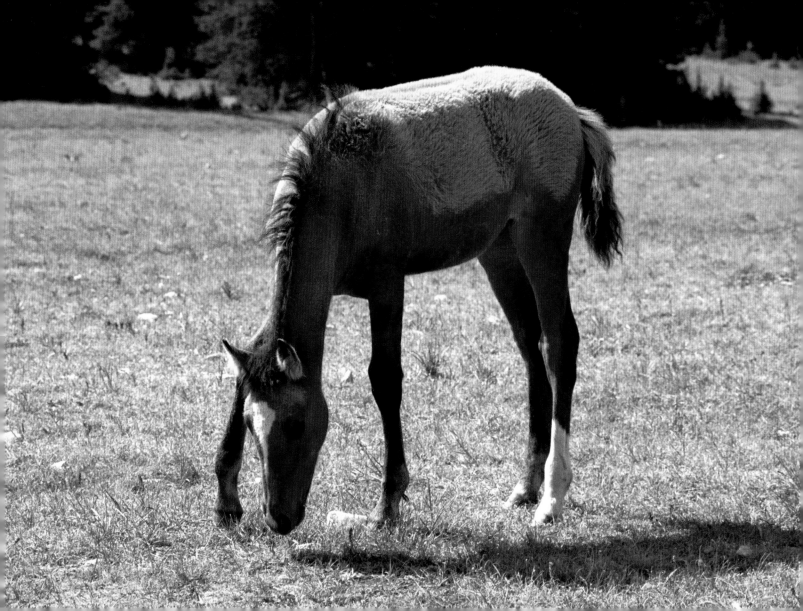

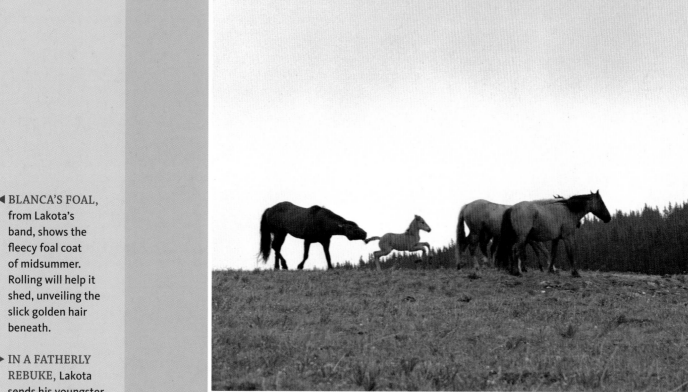

◀ BLANCA'S FOAL, from Lakota's band, shows the fleecy foal coat of midsummer. Rolling will help it shed, unveiling the slick golden hair beneath.

▶ IN A FATHERLY REBUKE, Lakota sends his youngster scampering back to its dam.

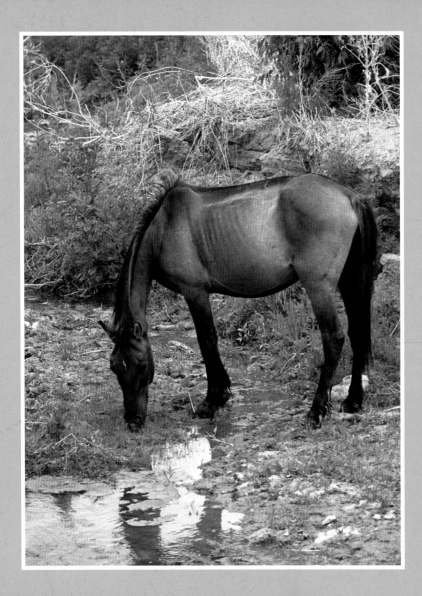

◀ ECHO, AN AGED MARE, found conditions on the Dry Head inadequate for survival during a drought year. She perished a few months after this photograph was taken.

▶ AFTER THE DEATH OF ECHO, his only mare, Sam steadfastly sheltered the foal they had reared. The stallion and tiny foal wandered together for weeks along the Dry Head, but late in the summer of 2004, the foal disappeared.

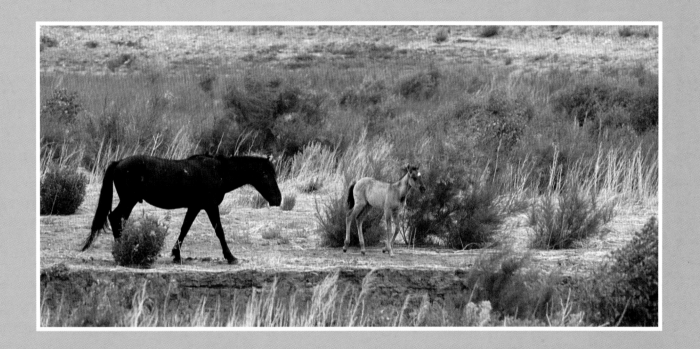

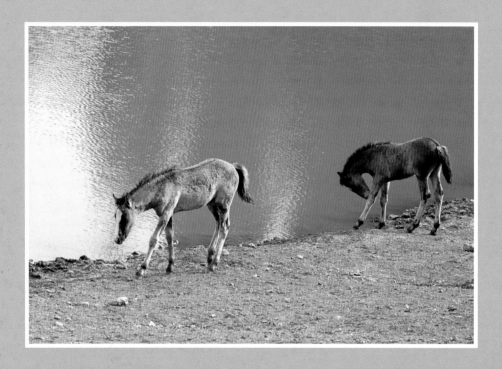

◄ **EVEN FOALS LEARN THE RULES** of water hole etiquette!

▶ **YOUNGSTERS ARE NO MATCH** for Cappuccino, the head babysitter of Starman's band. On this day he spent hours watching and entertaining foals. Note the prominent primitive markings on his withers, neck, and legs.

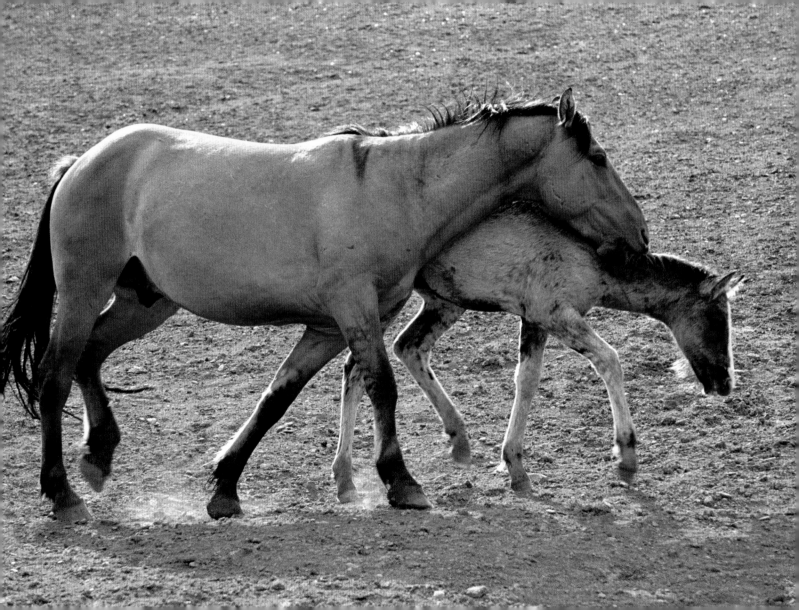

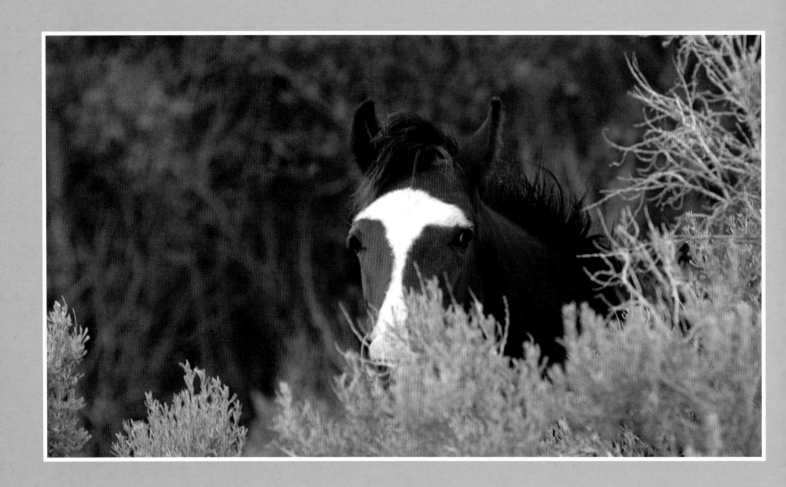

The only surviving foal of 2004,
Exhilarate (aka Bandito) peeks out
from sagebrush along a creek
in the Dry Head. He alone, out of
28 foals born that year, carries on his
ancestors' bloodlines. Nature
chose her favorites and left nothing
but ghosts of the rest.

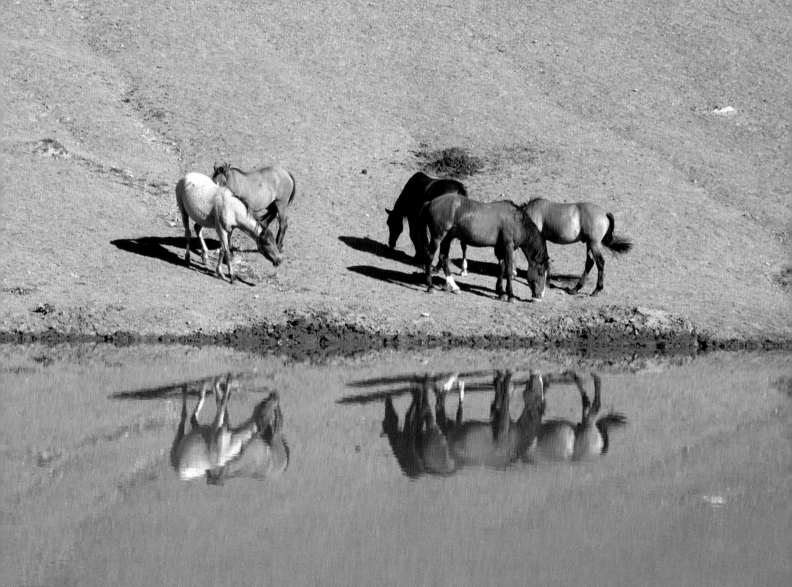

EPILOGUE

An Uncertain Future

THE BIGGEST CHALLENGE FACING THE PRYOR MOUNTAIN MUSTANGS is not the rugged land in which they live. Like that of all of America's wild horses, their biggest challenge is Man.

Wild horse management in America has a bloody past. Although many settlers cherished the tough, wily little horses as partners in the conquest of a vast new land, others saw them simply as competition with cattle. For decades the United States Grazing Service (later to become the Bureau of Land Management, or BLM) authorized shooting wild horses on sight. Wild horses once blanketed the plains, thriving in the land of their forefathers. By the late 1960s, it became clear that generations of merciless slaughter had all but wiped them out. The voice of the American people — appropriately enough — finally demanded their freedom.

With the signing of the Wild Free-Roaming Horse and Burros Act of 1971, the agency that once oversaw the annihilation of wild horses became responsible for their management. Today there are only about half as many wild horses as when the law was passed to protect them.

The Pryor Mountain Wild Horse Range falls under BLM, U.S. Forest Service, and National Park Service management, all of which juggle the health and well being of the horses there with other values. Due to these multi-agency and multi-use agendas, the Pryor Mountain mustangs are restricted to a much smaller, less productive range than they roamed when the law was passed. The BLM reports that this area cannot presently sustain the number of horses on the Range.

Proposed solutions include downsizing the herd or expanding the range (including the herd's original grazing areas in the Custer National Forest). Only adequate range expansion can naturally ensure the long-term health and genetic diversity of the Pryor Mountain mustangs. Although they have adapted to all of Nature's challenges in order to survive in this place, it is ultimately mankind that will decide their fate. Their future remains uncertain.

BACHELORS CIBEQUE, MEDICINE BOW, AND STARBUCK (from left to right) will live out their entire lives along the red rocks and sage of the Dry Head.

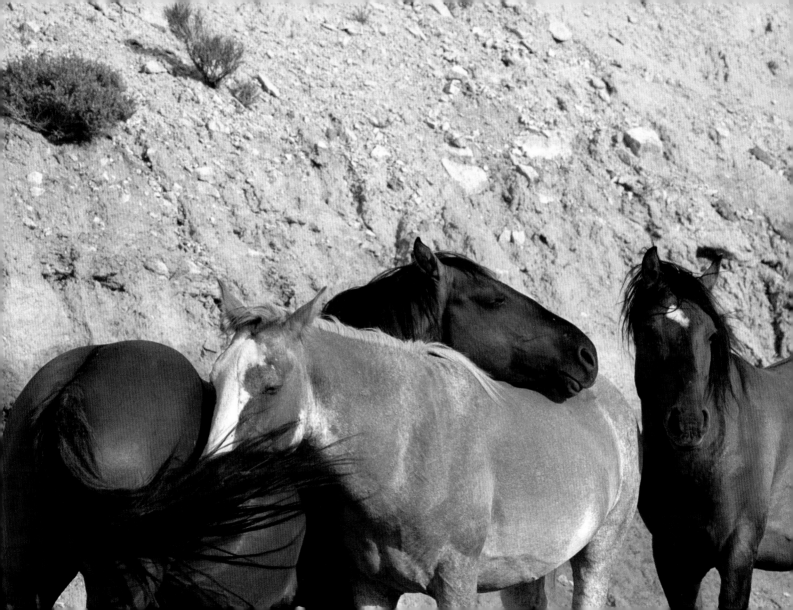

Bibliography

Bibles, D. Dean, Montana State BLM Director. "Origin of Pryor Mtn. Horses." Typewritten memo to BLM District Manager, Billings, MT. 6 May 1968.

Brownell, Joan L. "Horse Distribution In The Pryor Mountains Region Preceding The Creation Of The Pryor Mountain Wild Horse Range." Billings, MT: BLM, November 1999.

Fazio, Patricia Mabee. "The Fight to Save a Memory: Creation of the Pryor Mountain Wild Horse Range (1968) and Evolving Federal Wild Horse Protection through 1971." Doctoral dissertation, Texas A&M University, College Station, 1995.

Graetz, Rick, and Susie Graetz. "About the Crow: Introduction to the Crow," in *Crow Country: Montana's Crow Tribe of Indians.* Billings, MT: Northern Rockies Publishing Company, 2000. see http://lib.lbhc.cc.mt.us/about/intro.htm.

Harvey, David. *A General Historical Survey of the Pryor Mountains.* Billings, MT: Bureau of Land Management, 1974.

McIllvaine, Billy. Personal interview with Patricia Mabee Fazio. BLM Billings Resource Area, Billings, MT, 25 October 1994.

Morison, Samuel Eliot. *Admiral of the Ocean Sea: A Life of Christopher Columbus* (Boston: Little, Brown and Company, 1949), p. 390. Quoted in Fazio, "The Fight to Save a Memory."

U.S. Department of Agriculture, Natural Resource Conservation Service. *Pryor Mountain Wild Horse Range Survey and Assessment.* Prepared by Matthew J. Ricketts, Rangeland Management Specialist, Natural Resources Conservation Service, Bozeman, MT. April 2004. See www.mt.blm.gov/bifo/whb/PMWHR/survey_assessment/index.htm.

Ryden, Hope. *America's Last Wild Horses.* Guilford, CT: Lyons Press, 2005.

Singer, F.J., and K.A. Schoenecker, compilers. *(2000) Managers' Summary — Ecological Studies of the Pryor Mountain Wild Horse Range, 1992–1997.* Ft. Collins, CO: U.S. Geological Survey, Midcontinent Ecological Science Center, 2000.

Thomas, Dick. "Range Feud Swirling Over Wild Horse Herd." *The Denver Post,* 3 April 1966.

U.S. Congress. *The Wild Free-Roaming Horses and Burros Act of 1971.* Congressional Decree. Public Law 92-195, 1, 85 Statutes 649 (15 December 1971).

U.S. Department of the Interior. Bureau of Land Management. *Environmental Assessment (2005), Pryor Mountain Wild Horse Range, FY2005.* EA# BLM-MT-010-FY05-16. Billings Field Office, 2005.

———. Bureau of Land Management. *Herd Management Area Plan, Pryor Mountain Wild Horse Range.* Miles City District Office, Billings Resource Area. June 1984.

Williamson, Charles O. Letter to Norma Bearcroft, Canadian Wild Horse Society, July 12, 1967. (The entire text of this letter has not been located.) Reverend Floyd Schwieger Correspondence File, in possession of the archives of the late Reverend Floyd Schwieger, Lovell, Wyoming. Cited as Footnote #65 in: Brownell, "Horse Distribution In The Pryor Mountains Region."

Further Information

Living free is the birthright of all of America's wild horses.
Your voice can help ensure that their freedom remains a reality.
To learn more about preserving America's wild horses,
contact these organizations.

Pryor Mountain Wild Horse Range
Bureau of Land Management
Billings Resource Area
810 East Main Street
Billings, MT 59105
(406) 238-1540

Pryor Mountain Wild Mustang Center
P. O. Box 385
Lovell, WY 82431
(307) 548-WILD
www.pryormustangs.org

Pryor Mountain Mustang Breeders Association
P. O. Box 884
Lovell, Wyoming 82431
(307) 548-6818
www.trib.com/~daphneh/registry.htm

Wild Horse Advocacy Groups

The American Wild Horse Preservation Campaign
P. O. Box 926
Lompoc, CA 93438
(877) 853-4696
www.wildhorsepreservation.com

International Society for the Protection of Mustangs and Burros
www.ispmb.org

Society for Animal Protective Legislation
www.saplonline.org

Lifesavers Wild Horse Rescue, Inc.
23809 East Avenue J
Lancaster, CA 93535
(661) 727-0049
www.wildhorserescue.org

Animal Welfare Institute
P. O. Box 3650
Washington, DC 20027
(703) 836-4300
www.awionline.org

Photographer Lynne Pomeranz
www.lynnepomeranz.com
Equine & fine art photography

Acknowledgments

This book began with two women who had a passion for free-roaming wild horses. Since we had little preparation, our first adventures in the Pryor Mountains could well have been our last. But thanks to a few key people — as intent on seeing these magnificent horses preserved as we are — we lived to tell their tale.

Mere thanks cannot express our respect and gratitude. If not for these individuals, our experiences among wild horses might never have happened and could never have been shared with you. Our heartfelt thanks to . . .

Hope Ryden, for paving the way and persevering on behalf of the Pryor Mountain Mustangs.

Dan Elkins and the Mount Taylor Mustangs, for giving Lynne her first glimpse of horses in the wild.

Reverend Floyd Schwieger, for his dedication to preserving the Pryor Mountain mustangs and for freely sharing his knowledge and enthusiasm. He introduced us to them on an intimate, first-name basis. One of our greatest honors was to visit him in his final days, sharing one last round of stories of the horses on the Range, one last laugh and one last hug.

Patricia Fazio, for so many things: inspiration, direction, information, and attitude befitting the best lead mare on the Range. We can't imagine who could replace her and what she gives us.

Trish Kerby, who has generously shared her first-hand knowledge and touching life stories of individual horses. Her friendship and guidance on the mountain are invaluable.

Linda Coates-Markle, who has brought science and good conscience to the management of the herd. She brings a rare combination of caring and knowledge to a difficult, often thankless job.

Ian Tyson, whose lyrical tribute to wild horses set the tone, for his permission to reprint his words here.

All those in Lovell, Wyoming, who have befriended us, housed us, guided us and continue to keep us informed of the horses from afar: in particular, Joe and Joanne at the Horseshoe Bend Motel, Dale & Daphne Hartman, John Nickle, Jerry Tippetts, Kathy & Bill Johnsey, Nancy & Tom Dillon. And to Police Chief Mike McGee, who upon one of our first (mis)adventures said, "Lovell is that way."

Terri and Tony Wengert, for sharing this obsession with us.

Savannah Massingham and Sarah Poe, whose love of all horses kept Rhonda inspired.

Everyone at Storey Publishing, for taking on this project, especially Deb Burns for pushing for it to become a reality, and Mary Velgos, Liseann Karandisecky, Kevin Metcalfe, and Ilona Sherratt for their creative and technical expertise and enthusiasm.

Our families and friends, for their unconditional love and support.

And thanks especially to all those who have come before us in the spirit of preserving the legacy of wild horses and to all who will follow.

Horses Not Identified in Text

Page ii: Bachelors Cibeque, Starbuck and Medicine Bow, on the Dry Head

Page v: Foal of Echo, deceased, 2004.

Page 107: Bachelors, with Tecumseh bringing up the rear

Page 124: Trigger's band: (from left) BJ Star, Brooklyn, Evita, stallion Trigger (front) and Chai

Page 133: Lakota

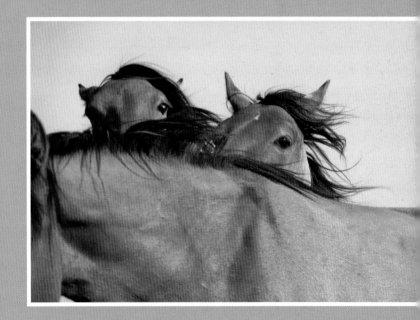

INQUISITIVE
YEARLINGS.
We're dun.

Artist's Statement

One day, on Mount Taylor in New Mexico, I caught my first glimpse of wild horses. There were three of them, all grays, and as soon as they caught sight or sound of our vehicle they galloped away through the rugged landscape in search of cover. Although the three disappeared in a matter of seconds, they left an indelible impression on my whole being. I experienced a sense of freedom, previously unknown to me, that made my spirits soar. Since that day I have been on a quest to document America's wild horses and to share their world with others through my photographs.

In contrast to the beauty of the horses and dramatic landscapes that are their homes, I have also experienced the political battles that surround the wild horse controversy. These are again precarious times for America's wild ones. As our country becomes more populated and land diminishes, the battle between various factions over land use becomes more heated. Wild horses often end up at the bottom of the bureaucratic totem pole.

Those of us who have witnessed the intimate world of wild horses fear for their fate and try in our different ways to turn the tides in their favor. There must always be a beginning point and the Pryor Mountain Wild Horse Range seemed the perfect place to start my journey in earnest. The Pryor Mountain horses are gracious subjects. Although wild in every way, they allow us humans into their world at fairly close proximity allowing an intimate view into the lives of wild horse populations in general. They have been chosen for this book to be the "spokeshorses," if you will, for all wild horses of both Colonial Spanish and mixed blood that roam this country. The ultimate beauty is the grace one experiences in the presence of the pure spirit and unbridled freedom that all wild horses portray.

To anyone who will listen . . . I am one of those humans who will exclaim endlessly that wild horses have changed my life.

—— Lynne Pomeranz

In Memory of Jan Bandler

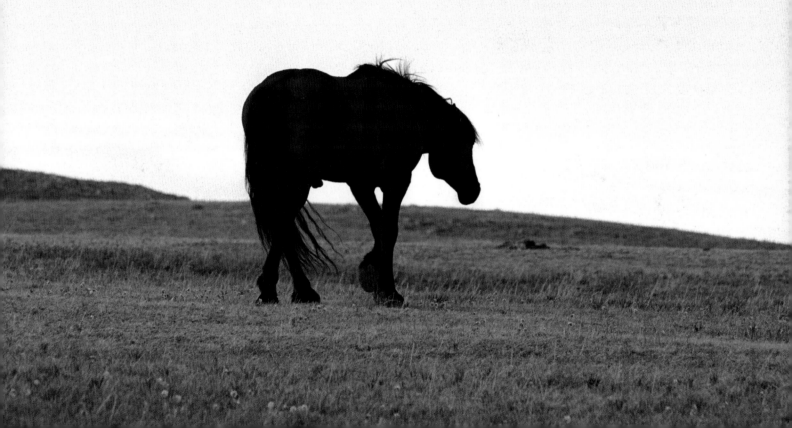

Facts about Wild Horses

Current wild horse populations represent approximately 1 percent of 19th-century U.S. herds. According to J. Frank Dobie's *The Mustangs* (Dallas: Southern Methodist University Press, 1952), more than two million wild horses roamed freely throughout the Great Plains during the 19th century.

By 1959, unlimited capture and slaughter had so decimated the number of wild horses that Congress passed the first federal legislation to protect them, called the Wild Horse Annie Act after the nickname of the woman who spearheaded the legislation, Velma B. Johnston. This law, however, offered no protection for the horses themselves but merely prohibited the use of aircraft or motorized vehicles in capture. It also banned pollution of any watering hole on any public land or range for the purpose of trapping, killing, wounding, or maiming wild horses.

The 1971 Wild Free-Roaming Horses and Burros Act (quoted on page 106) granted protection to the wild horses themselves, as Congress declared them to be "living symbols of the historic and pioneer spirit of the West."

Following passage of the 1971 Act, an estimated 303 herd areas were created. Wild horses have been removed from about one third of those original herd areas since then, and only an estimated 186 areas remain. Wild horses have been eliminated from roughly 12.5 million acres of the land originally set aside for them by law. Land area statistics vary considerably, however, depending on the source.

In 1974 a Bureau of Land Management census estimated that 45,207 wild horses and 14,656 wild burros lived on BLM and U.S. Forest Service lands. As of February 2005, that number had decreased to approximately 27,369 wild horses with 4,391 wild burros.

Under BLM's Adopt-A-Horse Program, the public can adopt wild horses captured in roundups. They are freeze-branded on the neck area for identification. Even with court-ordered regulations in place to protect them, however, freeze-branded horses often end up at slaughterhouses, once title has passed from the BLM to the adopter.

In 2004 a stealth rider (now called the Burns Amendment) attached to an appropriations bill removed 34 years of federal protection of wild horses from slaughter. In addition to holding regular adoptions, the BLM can now sell any excess animal, or its remains, if the animal is older than ten years of age or fails three adoptions. These wild horses are made available for sale without limitation — meaning that they can be sold at auction for slaughter, without adoption.